PRINT WORKSHOP

Copyright ©2010 by Christine Schmidt

Published in the United States
by Potter Craft, an imprint of the
Crown Publishing Group, a division
of Random House, Inc., New York.
www.crownpublishing.com
www.pottercraft.com

POTTER CRAFT and colophon is a
registered trademark of Random
House, Inc.

Library of Congress Cataloging-in-
Publication Data

Schmidt, Christine.
Print workshop : hand-printing tech-
niques and truly original projects /
Christine Schmidt.
p. cm.
Includes bibliographical references.
ISBN 978-0-307-58654-4
1. Handicraft. 2. Relief printing. I. Title.
TT857 .S32 2011
745.5--dc22
2010022305

Printed in China

Design by MacFadden & Thorpe
Photography by Douglas Adesko
Technical Editor: Judith Durant

10 9 8 7 6 5 4 3 2 1

First Edition

PRINT WORKSHOP

HAND-PRINTING TECHNIQUES + TRULY ORIGINAL PROJECTS

WRITTEN
AND
ILLUSTRATED
BY
CHRISTINE
SCHMIDT

POTTER
CRAFT

New York

CONTENTS

INTRODUCTION

Bills, bank statements, and junk mail arrive like clockwork, and seconds later they are relegated to a file folder or the trash. Newspapers and magazines, even those whose crisp pages we once turned with eager interest, eventually are tossed unceremoniously into the recycle bin. As the years pass, it seems that many of these items don't need to be printed at all and can be presented on screen, because the value of these pages is not the printing but the information presented. Churned out en masse by machines, most printing passes through our daily lives with little impact or notice.

But there's a flip side to that coin. Viewing a print that has been crafted by hand can be transforming. It embodies the art of printing. To behold a handmade print is to marvel at its intrinsic aesthetics, as well as the time, skill, and intention that brought the work of art into being. To go even further and create a handmade print yourself can be a sublime experience, metamorphosing your ideas into indelible images.

In this book I share the media and techniques, both ancient and modern, to create all kinds of prints: block, stencil, sun, and image transfer prints. These prints are unique works of art, interesting enough to be mounted on a gallery wall but presented in a format that can be used in your everyday life.

They say the spaces you inhabit say a lot about you. As anyone who has come to my studio can tell you, my space screams, "This chick is all over the place." Rather than concentrating on one discipline, I work in different art forms to create prints in a variety of media: photography, sculpture, and textile design in addition to traditional printmaking. The line of goods for my business, Yellow Owl Workshop, includes prints, stationery, stamps, and ceramics of my own hand and design. Naturally curious but easily bored, I move between

disciplines to keep interested in my work. And now that my work is printing for love and for a living, I have the enviable luxury of printing all day long. What follows in this book is basically what I would tell any interested party in a studio visit. Second to the thrill of creating work, I like sharing my tricks and discoveries. It's like spreading a more positive version of gossip.

In my opinion, beauty is just the name of an aisle in the drugstore, and it should stay that way. It's important to remember that when you're printing, beauty will always be a subjective term, and perfection can as often as not come from the imperfection of a piece. I am only a better printer because I have accepted and adapted to my printing missteps. How many prints have I ruined with an errant thumbprint or ink spill? Thousands. And my business depends on prints. So be positive about your new prints even if they aren't exactly as you envisioned. Remember, machines turn out perfect and perfectly boring prints all the time—and we already discussed where most of them end up.

HOW TO USE THIS BOOK

I have adapted all projects in this book for the home printer through years of trial and error working in my own studio. With each project, I've tried to share a bit about my creative process, not because I think I am so interesting, but because my logic and missteps may help you dream up and create your own projects. In other words, I try to share my inspiration because inspiration is not some mystical, divine influence; it is usually just some form of logical problem solving. Sometimes the inspiration comes from an interesting shape or image that compels me. Sometimes I need a present for a birthday party that starts in an hour. Both forms of inspiration are equally important, whether you print for fun or for your own business. But these projects aren't about me, they're about you. To that end, I try (to the best of my ability) to always put forth accessible instructions and an informed discussion of materials.

You'll also notice that the book contains templates for many of the projects. But keep an open mind! Many of the templates can work for other projects besides the one indicated in this book.

In fact even templates you make yourself have a life beyond a single project. Think about it: A silhouette you create in the stencil chapter would also make an interesting cyanotype or iron-on decal for a T-shirt.

The one word of concrete advice I will provide about mixing and matching designs is this: You won't be able to see a giant pattern on a really small surface. A tiny, delicate motif would be better printed on stationery where it can be examined up close, not on a giant wall where it would be lost. And it would take you a million years. So when selecting an image for printing, consider the size of the image and what you want to print it on (the substrate). Each printing process has its advantages and limitations, and I can help you see many of those. This book is intended to inspire you to create your own projects.

PRINTING PROCESS

Printing method	Colorant (ink and paints used)	Optimal designs for printing	Substrate (printing surface)
Found object stamping	Stamp pad, acrylic, screen printing ink, block printing ink	Found nonporous surfaces	Uncoated paper, watercolor paper, rice paper
monoprinting	Block printing ink	Simple to highly detailed designs	Uncoated paper, watercolor paper, rice paper
Vegetable stamp printing	Stamp pad, acrylic, screen printing ink, block printing ink	Simple designs using vegetable shapes or geometric designs	Uncoated paper, watercolor paper, rice paper
Linoleum block printing	Block printing ink	Simple to highly detailed designs	Uncoated paper, watercolor paper, rice paper
Wood block printing	Block printing ink	Simple to highly detailed designs	Rice paper, moistened watercolor paper, vellum
Frisket stencil	Acrylic, screen printing ink	Simple to highly detailed designs	Watercolor paper
Contact paper stencil	Acrylic, screen printing ink	Simple designs	Wood, drywall, fabric
Masking fluid stencil	Watercolor paint, gouache, or liquid inks	Simple designs to intricate line drawings with detail	Uncoated paper, watercolor paper, rice paper

Silk screening	Acrylic, screen printing ink	Simple designs to intricate line drawings with detail	Uncoated paper, watercolor paper, rice paper
Paper tape stencil	Acyrlic, latex	Simple shapes and lines	Wood, drywall
Mylar stencil	Acrylic, latex, screen printing ink	Simple shapes	Uncoated paper, watercolor paper, rice paper, wood, drywall
Cyanotype printing with found object	Prussian blue cyanotype sensitizer	Objects with one flat side with interesting shapes and lines	Treated watercolor paper, fabric, or wood
Cyanotype printing with created film positive	Prussian blue cyanotype sensitizer	Found nonporous surfaces	Treated watercolor paper, fabric, or wood
Cyanotype with digital film positive	Prussian blue cyanotype sensitizer	b/w artwork with high contrast and dense blacks	Treated watercolor paper, fabric, or wood
Screen printing with StencilPro™	Block printing ink	Anything! From simple designs to photographs	Uncoated paper, watercolor paper, rice paper
Solar plate block printing	Stamp pad, acrylic, screen printing ink, block printing ink	Found nonporous surfaces	Uncoated paper, watercolor paper, rice paper
Pin prick printing	None	Simple shapes and lines	Any paper or board
Image transfer with Ad marker	Ink on paper from laser or photocopier	Anything! From simple designs to photographs	Uncoated paper
Image trasfer with Sheer Heaven	Ink on Sheer Heaven paper from inkjet printer	Anything! From simple designs to photographs	Uncoated paper, watercolor paper, rice paper
Printing with transfer paper	Pigment transferred from transfer paper	Simple to highly detailed one-color designs	Uncoated paper, wood, drywall, some fabric
Water slide decal printing	Ink on paper from laser printer or photocopier	Anything! From simple designs to photographs	Uncoated paper, watercolor paper, rice paper
Iron on decal printing	Ink on paper from inkjet or laser printer	Anything! From simple designs to photographs	Cotton fabric, canvas

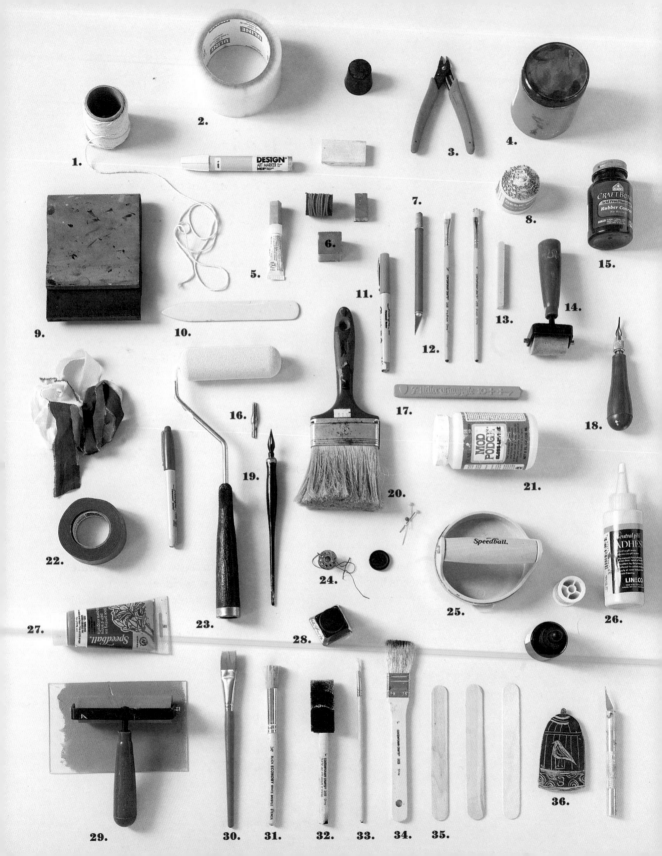

SETTiNG UP YOUR STUDiO

1. Cotton twine
2. Clear packing tape
3. Wire cutters
4. Screen printing ink
5. Super glue
6. Gum eraser
7. Craft knife
8. Straight pins
9. Squeegee
10. Bone folder
11. Marker
12. Synthetic brush
13. Chalk pastel
14. Rubber brayer
15. Rubber cement
16. Linoleum gauge
17. Sealing wax
18. Linoleum carving tool
19. Calligrahy pen
20. Paint brush
21. Mod Podge
22. Blue painter's tape
23. Foam brayer
24. Thread and needle
25. Barren
26. PVA glue
27. Block printing ink
28. India ink
29. Rubber brayer and palette
30. Flat brush
31. Stencil brush
32. Foam brush
33. Detail brush (round)
34. Paint brush
35. Popsicle stick
36. Rubber printing block

Jasper Johns used a converted barn for his studio.
But for those of us who don't have an extra barn, there is hope. For the most part, you can print in a room that's usually used for something else—or take it outside! Desks are nice, but the width and length of kitchen tables (or floors) are better. As someone who's lived in both New York and San Francisco, I know the value of space, and I have tried my best to make this book as friendly to city mice as to country mice. Just cover your work surface with a large canvas drop cloth or sheet of kraft paper to protect it from the inevitable spill.

GENERAL MATERIALS
A lumberjack wouldn't set off to a forest with a butter knife. A punk band wouldn't fill a stage with French horns and clarinets. Each trade has its exacting standards and tools, and so does printmaking. You'll save yourself time, energy, and frustration if you go with the good stuff. I'm going to give you all the info I have on what makes a certain tool right for the job.

CRAFT KNIFE
A sharp blade will make cleaner cuts and is less prone to slipping than a dull blade. It seems counterintuitive, but a sharper knife keeps fingers safer. So spring for the extra blades—you need to change them more frequently than you think. And hold that knife as you would a pen, at a 45-degree angle to the work surface and a 90-degree angle from your body. For cutting heavy board, use a utility or box knife.

CUTTING MAT
Cutting mats are meant to protect your table or other work surface from craft-knife blades. Chipboard (like the kind found on the back of sketch pads) or a sheet of glass will work, but I recommend self-healing cutting mats with grid lines; they're not only durable, but the marked measurements make them a handy work surface.

SCISSORS

This is the most versatile item in any studio. Paper has stiffeners that wear a blade down much more quickly than fabric does, so if you often work with fabric it is a good idea to hide a pair just for fabric in your sewing box. Pinking shears can also be useful; they have a saw-toothed surface that cuts a zigzag pattern instead of a straight line. They are used to prevent fraying of unfinished fabric edges and to give a utilitarian look. Fiskars® and Gingher are good brands of scissors to look for. If you decide to really splurge, remember that good-quality scissors can be sharpened and should last a long time.

TAPE

Not all tapes are meant for every job. Even duct tape can't be used for everything! (In fact, duct tape is impossible to remove from paper and leaves a gummy residue on most surfaces, so I rarely use it in the studio.) You'll want to select the tape according to the material you need taped and how long it should stay that way. For temporary taping and masking of paper, fabric, and wood, I use archival drafting tape (for more on the reason for, and benefits of, archival-quality materials, see page 16). It's less adhesive than packing or duct tape, so you can remove it without ruining your piece. Blue painter's tape is also a favorite of mine for wood, and it's made for temporary use on walls, so go ahead and buy this stuff for any mural work. Last but not least: Test whatever tape you're using on a piece of scrap paper first to make sure you can remove it without tearing your work surface or leaving behind adhesive residue.

MEASURING TOOLS

For most of the projects in this book, a simple straight-edge ruler works fine (unless the materials list specifies otherwise). If you need some help with angles, a protractor will do the trick. Personally, I prefer T-squares over rulers because, like a ruler, they have marked measurements, but they provide a straight edge that can be used for making cuts perpendicular to the table surface using a craft knife. If you're working on a big project, you can use a flexible measuring tape. Always remember the other golden rule of craft: Measure twice, cut once.

ADHESIVES

The same advice I gave about tape goes double for other adhesives. Your choice of adhesive should always be determined by the materials you want to bond and how long you need that bond to last. For gluing paper to paper permanently, I recommend polyvinyl acetate (PVA) glue, which is archival and dries clear and flexible without wrinkling the paper. If you need to glue two porous surfaces together (such as paper, wood, canvas, glass, and/or clay), use super glue. Mod Podge® (a brand name for a matte or gloss acrylic medium that has medium viscosity) is the way to go. When it dries, Mod Podge also works as a sealant to protect surfaces from moisture. If you have large areas of porous surfaces that need to be glued, you can also use 3M™ Super 77™ Multipurpose Adhesive. Always use a temporary spray adhesive such as Sulky Zoo if you don't want a permanent bond. The spray adhesive is lower in moisture content so it won't warp paper, but it is not archival. I use super glue or epoxy when I want to permanently bond two unlike materials, such as a linoleum block to a piece of wood.

SEALANTS

Sealants are used to create a protective coating. Krylon® Workable Fixatif, or Krylon Preserve it!® which comes in an aerosol cans, are my choice for sealing chalk, pastel, and pencil on paper.

Duct Tape

Full Spectrum Bulb

Archival Drafting Tape

Staples

Staple Gun

Scissors

Scissors

Mod Podge Gloss

Mod Podge Matte

Craft Knife

Extra Blades

Bone Folder

T-Square

As mentioned above, Mod Podge is also good for sealing some porous surfaces. Wood, metal, and fabric can also be sealed with mineral oil or clear paste wax. Mineral oil, available at any drugstore, is better for sealing than olive or vegetable oil because it is clear and odorless and doesn't absorb moisture from the air. When you shop for clear paste wax, try to find a brand that uses only a natural wax like carnauba. Mineral oil and clear paste wax can be used on paper, but I don't recommend it. They both tend to make paper transparent, and even if that's the desired effect, neither one is archival.

LEVEL

Use a level that reads both vertically and horizontally. The most exquisitely printed art will look wonky if it is not hung with a level.

STAPLE GUN

Keep that weakling desktop model at the office. A simple staple gun with ¼" (6mm) staples costs less than twenty dollars and will get you through most jobs.

SCRAP PAPER

I save scraps of all sorts of papers from my projects. Even if they're never used in a finished project, they're perfect for testing a paint color or trying out a new design or technique.

BONE FOLDER

Shaped like an incisor tooth with a long, rounded flat shaft, this tool has many purposes. The roundish pointed end is used to score paper for folding (think greeting cards) while the other rounded edges are meant for burnishing.

APRON

All the threads I own have a colorful paint patina, but this messy artistic wardrobe is not for everyone. It is true that water-based inks almost always will come out of clothing with some stain remover and a warm wash, but why take the chance? Plus, nothing says, "Can't you see I am working!?!" like an ink-splattered apron.

LIGHT

This might sound like a trivial thing, but the type of light you work under can make a big difference. Sunlight is full spectrum light, which means it shows colors the way our eyes read colors. That's why working in sunlight is ideal. Working under incandescent bulbs, which emit a yellowish light, and fluorescent bulbs, which emit a greenish light, will not let you view the hues of your colorants or substrates correctly. If you can't work by sunlight, it's best to get a work lamp with a full spectrum bulb to mimic sunlight.

PAINT PALETTE

A paint palette can be made of any nonporous flat surface, like a large plate or a cookie sheet. I use a sheet of glass about 8" by 10" (20.5cm by 25.5cm), which I picked up from the frame shop, because it is easy to clean and difficult to scratch.

PAINT MIXING TOOL

Palette knives are little flexible-head metal spatulas used to mix paint on a paint palette. Popsicle sticks can also be used. Watercolor paint is mixed directly on a palette with the wet brush. Latex paint is mixed with a large paint stick.

CHOOSING YOUR SUBSTRATE

Substrate is just the fancy-sounding word for the surface that will be printed. It's important too, since the same printed design will look different in color and texture depending on the tactile quality of your substrate. For example, absorbent substrates like watercolor paper or cotton cloth will require more ink, and some substrates have

texture that will show through the print. In general, you always want some form of texture, though. If your surface is too glossy, it often doesn't allow the print to set, and your design will smear, run off, or—even worse—never be fully dry.

If it's possible, I always pick up a little extra substrate to practice with, and you should too. My mail carrier would tell you that I am a fan of online shopping, but I always buy my substrates in person the first time, so I can accurately judge the texture, color, quality, and stiffness of the surface I will be printing on.

There are many choices for substrates, each with distinct advantages and disadvantages.

FABRIC

Gigantic fabric stores can seem like their own special version of hell. Bolts of gaudy fabric reeking of bizarre chemicals are piled haphazardly to the ceiling of some room lit with a single flickering fluorescent bulb. Whether you're in one of these fabric depots or just your local chain store, the varieties of content (synthetic or natural), surface decorations (solid or print), and textures (rough or smooth) can be overwhelming. I have learned that when I am faced with such a scenario, it's best to put my head down and march to the natural fibers section and look only at the solids. Since the printing processes we use require the use of heat to set the design, and the heat would melt synthetic fibers, going natural is an easy choice.

But what about the weave? Well, that's up to you, and it depends on what you want your print to look like. When I want crisp and consistent prints I go for finely woven cotton fabric. When I want a more utilitarian look, or if I want to use the rough texture to my advantage in my printing, I go for canvas or linen. Whatever you decide to buy, always, always wash, dry, and iron fabrics before printing. Washing will remove sizing (a stiffener) and shrink the natural fabric a little bit.

PAPER

Unlike the fabric stores, shops with an organized variety of papers deserve hours of my time. I love to leaf through their well-organized, well-lit selections. The paper spectrum can be staggering, but unlike fabric, you can print on nearly all of it (with the exception of glossy and metallic-coated paper). I usually go for either Japanese *kozo* (mulberry paper) or watercolor paper because of their texture and absorbency. When I want a very detailed print, I make sure to find paper with the smoothest possible surface, such as hot press watercolor paper, which is usually smoother than cold press watercolor paper. However, sometimes it's fun to experiment and use some kraft paper with a little tooth that will show through the print.

There's another aspect of paper to consider too: weight and caliper. Paper weight is measured by taking a stack of 500 identically sized pages and measuring the weight (given in either pounds or grams) and height (expressed in thousandths of either an inch or millimeter). Usually, the thicker the paper, the higher the weight. For example, regular copy paper is 20 lbs per square meter. Anything over 100 lbs per square meter is considered card stock. Certain techniques require specific paper, but if I'm making stationery or something to be handled, I usually prefer the feeling of the thickest paper possible.

WOOD

Wood, if it has a smooth unfinished or painted surface, can be awesome for printing. Just make sure to avoid woods with a glossy polyurethane or lacquer finish. (The finish can be sanded off or removed with chemicals, but timewise and healthwise, it's not worth it.)

Before printing on wood, sandpaper should be used to prep the surface. Sandpaper is pretty simple to figure out: The larger the number on the package, the more particles per square inch and

What Is Archival Paper?

Anybody who has seen a newspaper quickly yellow and stiffen in the sun has seen the effects of paper that is not archival. Papers, colorants, and adhesives that are listed as archival, or acid free, are ideal for projects that you want to keep around a long time. The pH scale measures how acidic or basic (alkaline) a solution is on a scale from 0 to 14; paper that is acid free has a pH of 7 (neutral) or slightly higher.

Most paper is made from wood, which contains a compound called lignin. Paper that is acid free or archival has had the lignin removed. If you don't know if a given paper is acid free, you can test it with a pH pen from the art store: Make a little mark on the corner of the paper with the pen; if the mark changes color, the paper is not acid free and it will degrade over time.

Archival is also a word you want to keep in mind when it comes time to frame or mount prints. Always get an archival mat and use archival tape or glue to make sure the entire package will last as long as the print does. If you're entrusting the task to someone else, asking your framer to use UV (ultraviolet) glass will further protect it from the damaging rays of the sun—which will extend the life of any print. All that said, I often choose paper that is not archival. Sometimes I use the yellowing of the paper to my advantage for a print with white ink, or I use discolored found paper as a design element in my composition. Rules are for breaking anyway, right?

the finer the grit. Rough wood—gnarly, bumpy stuff—will need to be worked with coarse grit, then medium grit, and then finished with fine grit. Smoother wood, like the kind found in craft stores, probably just needs some fine grit worked back and forth. Sand in the direction of the wood grain. After the sanding, wipe off the dust with a dry cloth or a cloth moistened with a little rubbing alcohol. Whatever you do, don't use water! Water raises the grain of the wood and makes the surface texture uneven. As long as you don't soak your cloth, alcohol evaporates quickly and leaves the surface flat.

Now that your wood is ready, make sure you are too. Thin inks, like watercolor paint, will bleed along the wood grain. For a print that holds its line quality, you need to have acrylic paint, block printing ink, or latex paint on hand. As mentioned under sealants, wood needs to be sealed after printing with mineral oil, wax, or Mod Podge. Sealing not only protects the print, it usually brings out the contrast of the wood grain.

DRYWALL AND PLASTER

Drywall and plaster walls are great for printing. If your wall has never been painted or was painted a darker color than the ink you want to use, you'll want to coat it first with primer. Once your wall is ready, fill a bucket with hot, soapy water and wipe the entire surface down. Walls that are not completely smooth can be used with some printing processes, but the texture will show through.

GLASS

With the right preparation, glass can be used for some printing methods. The glass must first be cleaned with soap and water and then carefully wiped with rubbing alcohol. Next, a layer of gloss Mod Podge or gloss acrylic medium should be painted on with a brush. The acrylic or Mod Podge will act as a primer, allowing the print to stick to the glass surface.

COLORS

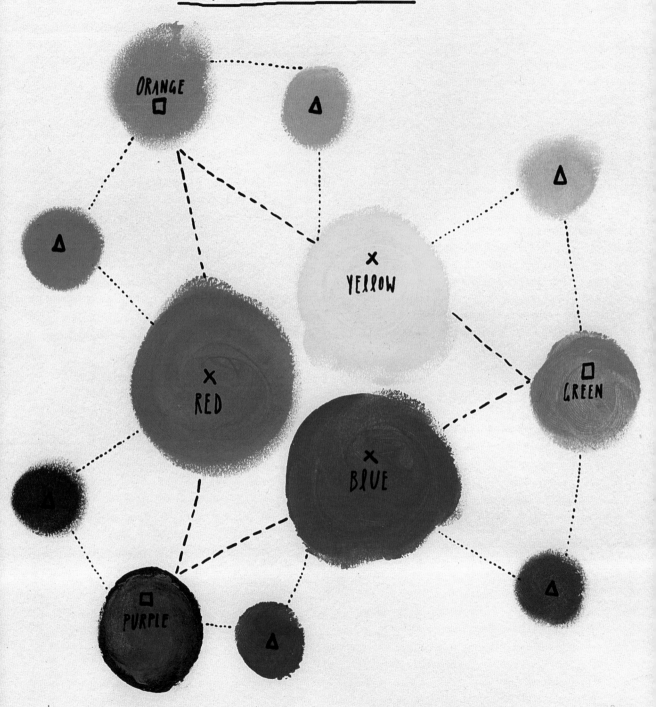

ORANGE □

YELLOW ✕

RED ✕

BLUE ✕

GREEN □

PURPLE □

✕ = PRIMARY
□ = SECONDARY
△ = TERTIARY

INKS AND PAINTS

Colorants are liquids or gels that contain natural or synthetic pigments used to add color to an object. Inks and paints are the most common colorants; they use a vehicle (usually water, acrylic, or natural gums) to suspend a pigment in solution. In this book—and in my own work—I use water-based and water-soluble colorants so I can easily clean up with soap and water. Oil-based paints and inks require nasty solvents that are not well suited for home use.

Even if two colors are labeled or look the same, different brands of ink and paint will almost always produce different variations of a color when you print. That's because each brand uses a different shade and strength of pigment to create their own colors. To make sure you get the result you want, make sure to test any ink you haven't used before on scrap paper before you print. Acrylic and latex paint come in a full spectrum of finishes as well, running from "flat" (no shine) to "high gloss" (very shiny.)

LIQUID ACRYLIC PAINT

This paint is a good choice for most surfaces. It can also be watered down and used like a watercolor on absorbent paper. Any acrylic paint can be used on fabric if Liquitex® Fabric Medium is added to the paint.

SCREEN PRINTING INK

This ink is available in both regular (poster or paper) and textile varieties. Either type can be used on paper or fabric, but the textile version must be used on fabric if it will be washed. The textile ink also requires heat setting with an iron after printing. I usually buy the Speedball brand textile ink because the price and the quality are just right and I have the option of printing on fabric.

BLOCK PRINTING AND INTAGLIO INK

This ink is great for relief printing on paper because it's thicker and gummier than acrylic ink. For small projects I like quick-drying Speedball or Dick Blick water-soluble block printing ink. For larger relief prints, where I want more working time with the ink on the block, I use Akua water-soluble intaglio ink. The intaglio ink doesn't contain any chemicals that speed the drying process so it can take several days, or even weeks, to dry. However, this lengthy drying time means more working time for large or complex prints.

LATEX PAINT

This is the paint to buy if you're printing on walls. It is actually a misnomer: these days, this paint is made with synthetic polymers like acrylic instead of natural rubber. If I am working with a small surface area, I just buy a can of neutral white base and add my acrylics to achieve the color I want. Check the label for the listed content of solids (around 40% for good opaque coverage) and little or no VOCs. These volatile organic compounds make the paint smell terrible, and these harmful compounds continue to be emitted even after the paint is dry.

ACRYLIC SPRAY PAINT

Although spray paint is good for some stencil applications, I rarely use it. The color palette is limited, and because it is contained in a can you can't mix your own colors. You also have to use it in a well-ventilated area. I do occasionally use spray paint (usually white or black) to prepare wood or other uneven surfaces for printing. If you do decide to experiment with spray paint, the advantage is quick coverage and even application—the spray nozzle creates a smooth (brushless) surface.

Why Is Some Paint So Expensive?

Ever go to the art store and wonder why the prices jump around from color to color, even in the same line of paint? It all comes back to pigment. Paints and inks vary in price according to the cost of the pigment or pigments used to create a particular color. Pigments can either be natural or synthetic. Natural pigments tend to be more expensive since they are often rare, hard to extract, toxic, or chemically unstable.

Even within the realm of synthetics there is hierarchy. Craft stores and art supply stores all sell different acrylic paints. If you need your project to have color permanence, go with the pricier stuff from the art store. Otherwise, try a few low-end and mid-range brands until you find one you like.

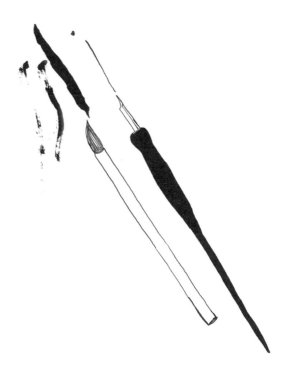

MIXING COLORS

Every single color imaginable can be mixed from just red, yellow, blue, white, and black. Doing it yourself is both fun and cost-effective. It just takes a little practice to figure out what combinations you like. Once you do, you'll probably start tweaking even your primary colors to make them your own. For example, I prefer my red and blue slightly on the warm side so I often add a touch of yellow.

A rule of thumb when cooking is to add salt slowly. You can always add more salt, but you can't take it away. When mixing paint, it's helpful to follow the same rule: Add colors bit by bit until you achieve your desired hue. Unlike cooking you can always add more of the base, but why mix more than you need? As I already mentioned, each brand of paint varies in the intensity of its pigmentation, so be aware that your proportions will probably change if you switch brands. Here are the basics:

- **Primary colors** are red, blue, and yellow.
- **Secondary colors** are made by combining two primary colors. Mix red and blue for purple. Mix blue and yellow for green. Mix yellow and red for orange.
- **Tertiary (also called intermediate) colors** are made of three colors, but usually just two components (one primary and one secondary). For example, blue-green is made with blue and green, and green itself is yellow and blue.
- **Color temperature** describes the warmth, or lack thereof, in hues found on opposite sides of the color wheel. Warm colors are yellow, orange, and red; cool colors are blue, purple, and green. This is different than tints and shades, which involve the addition of white or black to a color.

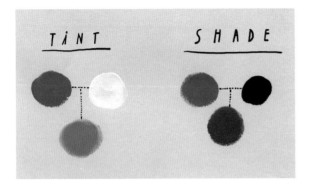

- **To make a tint,** begin with white ink and slowly add a pure color to achieve the color desired.
- **To make a shade,** begin with a pure color and slowly add the black ink. Black ink is very potent, so a little goes a long way.

Color palettes are generally classified by three different types.

- **Monochrome** uses tints (light) and shades (dark) of the same hue. Light blue and dark blue is an example.
- **Analogous** uses a range of hues found near each other on the color wheel. Red, orange, and red-orange is an example.
- **Complementary** uses colors opposite each other onthe color wheel, one primary and one secondary. The primary color blue and the secondary color across from it on the color wheel, orange, is an example.

DESIGN BASICS AND NOTES

The organization of visual elements in art and design is called the composition. The composition is made of both elements of design and principles of design. Like letters and words in a book, elements are the things in the composition. Principles are about the relationships between elements, a kind of visual grammar—or how words in a book work together to express ideas.

ELEMENTS OF DESIGN

These are the individual components that make up a composition.

- **Line** is any mark on a surface. It can be curved or straight, thick or thin, continuous or dotted, controlled or free hand, clear or blurry, and anything in between. Lines are used to define space. The "quality" of the line refers to the width.
- **Space** is the area within, around, or between objects.
- **Negative space** is the area between objects.
- **Shape** is space whose height and width have been defined by a line, a hue value, or texture. Shapes are flat, meaning they are two-dimensional. Examples are a circle, triangle, and square.
- **Forms** are shapes that have defined height, width, and depth. Forms are (or appear to be) three-dimensional, such as a sphere, cone, and cube.
- **Dimension** is the measurement of distance in space (near, far, front, or back).
- **Texture** is how an object feels or appears to feel (smooth, rough, soft, or hard).

- **Hue** is the name of a pure color as it appears in the color spectrum.
- **Value** is the brightness or purity of the hue as determined by its tint or shade.
- **Tint** is hue with white pigment added.
- **Shade** is how much black has been added to a hue.

DESIGN PRINCIPLES

Design principles are the way the elements are arranged in a composition. In printing, these are the main ones to consider.

- **Balance** is how symmetrical or asymmetrical the composition appears.
- **Pattern** is the repetition of elements, also called motifs, to create a visual rhythm. (See below for more information on types of patterns.)
- **Variety** is the difference between elements.
- **Proportion** is the relationship between one element and the composition.
- **Contrast** is the difference between two elements.
- **Unity** is the way all of the elements work together in the composition. In other words, if you add or remove an element, the harmony of the work would change.

PATTERNS

Repeating one design element, such as a mark, line, shape, or color, makes patterns. Even the simplest motif can create infinite variations for patterns.

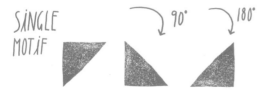

Single repeat is when motif is repeated along vertical and horizontal lines.

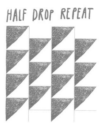

HALF DROP REPEAT

Vertical repeat or **horizontal repeat** is when a motif is repeated along either a vertical or horizontal line but staggered every other row or column.

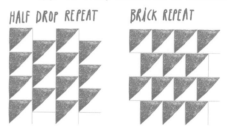

HALF DROP REPEAT BRICK REPEAT

Rotation repeat is when a motif is rotated around a single point. Many variations can be made by altering the degree of rotation.

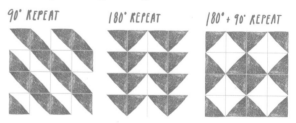

90° REPEAT 180° REPEAT 180° + 90° REPEAT

Random repeat is when a motif is repeated without discernible order or plan.

FINAL THOUGHTS

HOW TO SIGN AN EDITION

A series of prints is called an edition. An edition can be any size you want it to be, but prints that have small editions (a small number of prints) command higher prices because of their scarcity. Labeling and numbering proofs should be done once you've cleaned up your work space and your prints are dry. So we'll pretend that's the case, and you are ready to grab a pencil and make it official.

Say you made ten prints, and two of them were test prints to check colors and the orientation of your design on the page. These are called artist proofs, so you would write A.P. on the bottom left corner. For the remaining eight prints, number them accordingly on the bottom left corner of print: $\frac{1}{8}$, $\frac{2}{8}$, $\frac{3}{8}$, and so on. If you have created your prints in a variety of colors, it is a varied edition, so write V.E. to the left of the edition numbers. If you printed them all in the same color, you need just the numbers. If the print has a title, write it in quotation marks at the bottom middle of the print. Last but not least, sign first your name and then the date (month/year) on the bottom right. Some printmakers often follow the Eastern tradition of using a stamp with a carved name or initials in lieu of a signature. (You can learn how to make your own stamp on page 30.)

SOURCE MATERIAL

I've found that it helps to keep a physical record somewhere of all the images, text, and objects that interest me. A simple sketchbook or set of file folders full of source material usually does the trick when I need inspiration for a new design. I prefer the term *source material* because inspiration has some kind of magical air, and the things that make me want to print are definitely of this world. A paper towel with an unusual embossed pattern, a vintage postcard with a lion,

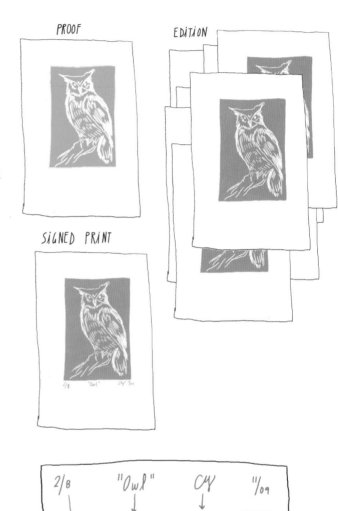

PROOF

EDITION

SIGNED PRINT

2/8 → NUMBER OF PRINTS

"Owl" → TITLE

CY → SIGNATURE

"/09 → MONTH/YEAR

and a book about hieroglyphics are all sitting on my desk as I write these words. I am not sure now why I need them, but something about each holds my attention and will likely find its way into my work somewhere down the line.

COPYRIGHTS ARE YOUR FRIEND

A copyright is the right that a person has to copy and distribute and profit from an original work. It protects us creative types from other people making money selling reproductions of our work. Copyright infringement usually involves instances in which people steal others' designs for commercial (not personal) use.

The moment you create an original artwork, the copyright is automatic, but some choose to pay a fee and record their copyright with the government. This provides more legal protection should somebody steal your exact designs, but it is usually unnecessary. If want to use another artist's images, try contacting them for permission. They might let you use it for a fee or a licensing deal in which they earn royalties. Don't fret; there are also clip art books that allow you to reproduce royalty-free designs for personal (and sometimes commercial) use.

Also, there are tons of images in the public domain that are free to include in your designs. Copyrights usually last for between 50 and 100 years, so if you want to adapt an older piece of art, it might be usable. To learn more about copyright, register your own work, or search for the work of others, visit www.copyright.gov.

The great thing about making your own prints is finding your own creative voice. Don't be afraid to make something "ugly" on the way to a new design. Just trust your brain and your hands and make something entirely original. After some practice, your own style will emerge complete with your own designs—ones that are copyrightable to you.

CRAFT VS. DESIGN VS. ART

This debate about the differences among craft, design, and art has been occurring for hundreds of years, is likely occurring at this second in hundreds of locations, and will be occurring thousands of years from now. The differences are evident, but their exact divisions are cloudy. It comforts me to know that there will never be definitive resolution, because my own opinions are just as cloudy. But like anybody who is passionate about these pursuits, I have an opinion.

Craft is the skill and technique used to create an object: the "how" something is made by hand with a specific medium. Design and art both use craft. Art and design are not separated by appearance but by aim. Design conveys information. Art conveys emotion. Design's goal is functionality: to serve a purpose such as informing or performing a task. It is all about utility. Art is its own function: art's goal is to encourage contemplation.

This is not a book about aesthetics or the study of experiencing a work of design or craft. For me the process of bringing something into existence is the reward. Every person in a creative pursuit—visual, musical, or literary—works for that rare moment when the structure of the medium falls away, leaving just you and "the making."

RELIEF PRINTING

You probably have already been a relief printmaker anddidn't even know it. Store-bought rubber stamps are the most accessible, inexpensive materials for relief printing. And we all know the process: Press stamp onto an ink pad and then press stamp onto paper. But relief printing is more versatile than you think.

Relief printing is where the eye-opening moment of creating original prints began for me. Although I had learned several basic forms of printing when I was young, I didn't realize the potential of the process until I took a relief printing class at the Kansas City Art Institute at the dangerously impressionable age of 16. With my well-honed teen apathy, I walked into that class hoping to objectify some art school boys and expand my portfolio for college applications.

I had always made drawings, and I found that carving my drawings into a relief plate brought a rich dimension to my work. Once I had a plate, the multiplicity of the printing process let me experiment and take risks without ruining my drawing. At the time, I thought art was really about showcasing technique. My goal was to learn a skill and work on it until I could display a capable understanding of it. But something about the slow cut of the carving knife, the tactile quality of the gummy ink, and the reveal of the finished print enthralled me. The experience moved me from art as mastering a technique toward art as expression. This is one of the reasons why relief printing has captivated mankind for thousands of years. And even though I lost my Fugazi mix tape years ago, my adolescent fascination with this process endures. So leave that old stamp and ink pad in your desk drawer. Carving your own blocks to make original relief prints is much more fun, versatile, and rewarding.

TOOLS AND MATERIALS

THE BLOCK

Vegetable: Potatoes and other root vegetables make for fine temporary stamps as long as you're using low-detail designs. Vegetables are either carved with a kitchen knife or linoleum cutters to create angular shapes. Carved vegetables can be stored in a sealed plastic bag in the fridge for two to three days.

Rubber block (A): The block I most frequently use is a rubber sheet similar in texture to a pencil eraser. The linoleum cutters carve this surface like butter, but it's not ideal for projects that require crisp detail or multiple block registration. A variety of manufacturers make these products, but you should only buy the ones with a smooth and blemish-free surface; my favorite is the Speedball® Speedy Carve block. Cheap versions can have a bumpy texture and crumble under the engraving tool. (I'm convinced these are manufactured for the purpose of aggravation.) After being carved, rubber blocks can be superglued to a clear acrylic mount, which lets you see where you are stamping, or a wood block for added block stability and ease of printing.

Linoleum block (B): These sheets of linoleum are sold mounted to wood. Some popular types—named for their colors—are battleship gray and golden cut. More rigid than the rubber sheets, these blocks are good for holding crisp detail and registering multiple layers. However, they can wear out your carving tools fast, so make sure to replace dull blades immediately! A dull blade can slip on the block, ruining your design (or worse, ruining you).

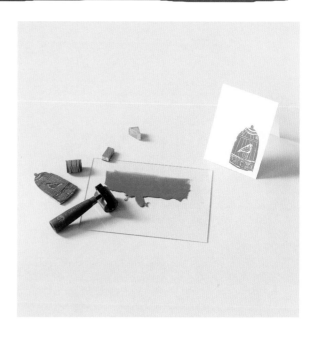

Wooden block (C): The most traditional form of block printing is done with actual wood blocks. Softwoods from evergreen trees, like spruce and pine, are relatively easy to carve, but because they are soft they don't hold detail well. Hardwoods from trees that lose their leaves seasonally, like cherry and poplar, require a more practiced hand to carve, but will hold strong detail through many impressions. The hard surface can be challenging (but rewarding) to carve, and the carving tools will require frequent sharpening. The texture of wood grain can add amazing depth and interest, but it is best to master the techniques using linoleum block first. (All of the projects in this book use linoleum and rubber blocks, which are easier to carve and more forgiving than wood, and the tools for carving those two surfaces are inexpensive and need no sharpening.)

Custom stamp: Sometimes cheating is allowed. In the Resources section (page 147) you can find places that will laser-engrave a stamp for you.

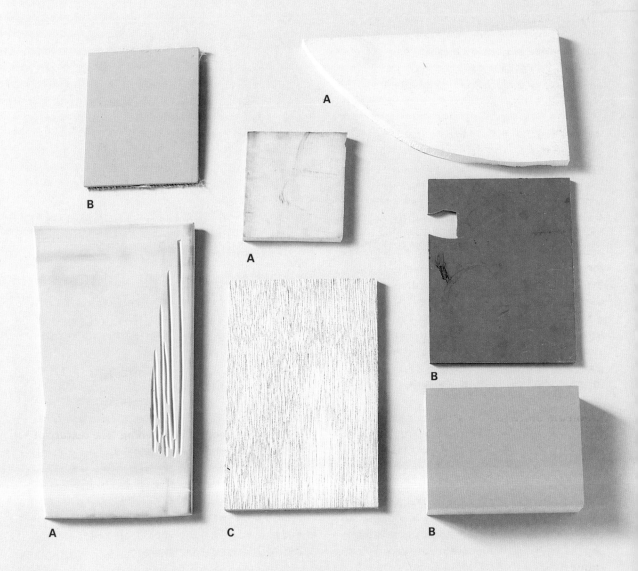

B

A

A

A

B

A

C

B

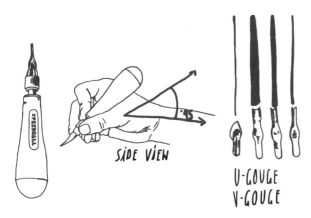

SIDE VIEW

U-GOUGE
V-GOUGE

CARVING TOOLS

Carving tools come in different shapes and angles and should be chosen after you have determined the block you're going to use. Hold all tools at a 45-degree angle and push the surface underneath with even pressure, making sure not to dip the top of the blade below the surface. Always push the tool with even pressure AWAY from your body to create a carved line. The shape and angle of the blade determines the width of line. Outlines and delicate drawings generally are carved first with a narrow V-gouge carving tool, and larger areas are then cleared out with a U-gouge carving tool that has a wider angle. Crisp lines can also be made by following a line with a beveled knife tool and then carving up to the scored line.

Knives: I wouldn't use a kitchen knife for anything but vegetable stamps or rubber erasers.

Linoleum cutters: Because linoleum and rubber sheets are softer than wood, they can be engraved with inexpensive tools called linoleum cutters. These tools use a handle with interchangeable blades that are disposable and require no sharpening. Linoleum is more rigid than rubber, so it dulls blades more quickly; always have replacements on hand.

Wood engraving tools: Although these are for wood (duh), they can also be used for linoleum or rubber. These usually come with sturdy wood handles and blades that must be sharpened with a special stone after use. With proper care, these quality tools can last a lifetime.

THE INK

I use water-based ink across the board in this book. Oil-based inks require solvents for cleanup, whereas cleaning up water-based ink just involves a quick soak and a scrub in hot, soapy water. The ink can be challenging to get off clothes, however, so wear an apron instead of your usual ball gown. The type of ink you use is based on the surface you are printing on.

Ink for paper: For relief printing on a very small scale, you can use stamp pads. Dye-based stamp pads are the most familiar, but they provide washed-out color that fades. Pigment-based pads are a step up and provide brighter colors that don't fade, but I still find the color palette limiting. I much prefer the richness of water-soluble block printing ink for printing on paper. It uses water as a solvent and suspends the pigment in natural gums. It is widely available in many colors, and a little goes a very long way. Water-soluble block printing ink dries more quickly than oil-based ink, so pick up a little tube of retarder and mix it with the ink to increase working time.

Ink for everything else: For surfaces other than paper, I use acrylic paint either in the form of liquid craft acrylics or textile screen printing ink. Any acrylic paint can be made into textile paint by adding liquid fabric medium (such as Liquitex Fabric Medium). Although manufacturers' instructions differ, most require heat setting with an iron and recommend waiting for at least four days after you print before washing.

THE BRAYER

Brayers are composed of a handle with a dowel on which a tube of rubber rotates. Just like the roller you might use to paint your house, this tool distributes the ink evenly. A larger block demands a larger brayer to create an even coat on the block, while a small block, such as a stamp, requires only about a 2" (5cm) brayer to spread the ink evenly. A good quality 4" (10cm) brayer will suffice for most projects. If you're buying just one, in my opinion a soft brayer is more versatile, because it can be rolled on uneven surfaces. However, high-density foam brayers are good when you need a thicker coat of ink and should be used with liquid acrylic ink on fabric or wood. Take care of your rubber brayers and clean them after use with warm soapy water and keep them out of sunlight; after prolonged exposure the nitric rubber can crack.

BRAYER

THE PRESS

Although many professional printmakers have access to a press, most of us are left to our own devices. Luckily, those devices are incredibly effective. A barren is an inexpensive handheld disk that is composed of coiled fibers or ball bearings on one side and a handle on the other. You simply press and rotate the barren in a circular motion, and the raised portions of the barren press the ink onto the paper or cloth. The back of a wooden spoon, pressed and rotated in a circular motion, also does a fantastic job—but be willing to lose it as a cooking utensil (trust me, nobody wants blue spaghetti). Some people use a simple kitchen rolling pin, but I find the lack of control and uneven pressure leads to very uneven prints. And don't forget that the most primitive press of all is turning these very pages: your own humble mitts. The side of your palm is the original barren, and your fingers, with a little bit of pressure, are a minipress for stamps.

THE SURFACE

Printmaking paper needs to absorb ink and hold up under soaking and printing. Western printmakers generally use cotton paper and oil-based ink. I go with the Eastern tradition of using water-based ink and Japanese paper made with kozo (mulberry bark). Often inaccurately called rice paper, this strong and semitranslucent paper is great for printmaking. High-quality handmade versions are called washi. Purchase paper that has been presized (sizing is a protective coating that keeps the ink from bleeding on the page).

If you're printing on fabric, remember that natural fibers are required for items you want to wash. That's because textile ink must be heat-set with an iron before washing, and synthetic fabric may melt in the heat-setting process. But all fabric should be washed before printing to remove sizing and allow for any shrinkage.

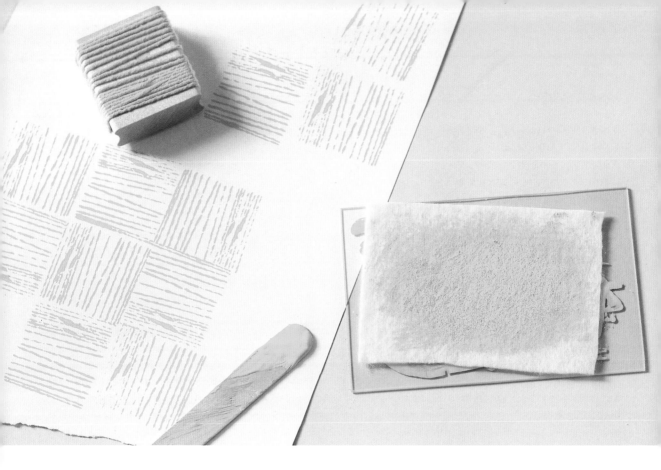

STUDiO STAMP PAD + BASiC BLOCK PRiNT

Stamp pads from the store are small and limit your choices of ink color and opacity. Here we mix our own rich hues to make a stamp pad. Alhough any liquid acrylic paint will do, I most often use textile screen printing ink; if I want to stamp on fabric, I just have to quickly heat-set it with an iron. The felt and the paint palette can be rinsed and used again and again. Use store-bought stamps, or create your own carved vegetable stamp (see the Veggie Picnic Set, page 41) or linoleum stamp (see Your Very Own Stationery project, page 44). The template for the stamp is provided on page 156.

MATERIALS

Popsicle® stick
Textile screen printing ink
Paint palette
Salt
7" (18cm) square of felt
18" x 24" (45.5cm x 61cm) piece of kraft paper
Rubber stamp
Scrap paper
Dish sponge (optional)

INSTRUCTIONS

CREATE THE STAMP PAD

1. With a Popsicle stick, dollop 3 tablespoons (44ml) of ink onto the palette and add a healthy pinch of salt. Within a minute the salt will draw much of the moisture out of the ink, making it the consistency of syrup.

2. Spread the ink out with the Popsicle stick and lay the piece of felt over the ink. The felt will absorb the ink, creating an evenly inked surface ready for stamping.

3. Repeat process when more ink is needed.

STAMP THE PAPER

4. Place kraft paper on a flat work surface.

5. Holding the stamp firmly, press it into the ink pad, then press firmly on scrap paper.

6. Repeat until you get an even impression on scrap paper.

7. Press stamp onto kraft paper in desired pattern.

CLEAN THE STAMP

8. Press the stamp onto moistened dish sponge to remove excess ink. If it is difficult to remove ink from small crevices, run under warn water and scrub gently with a soft toothbrush.

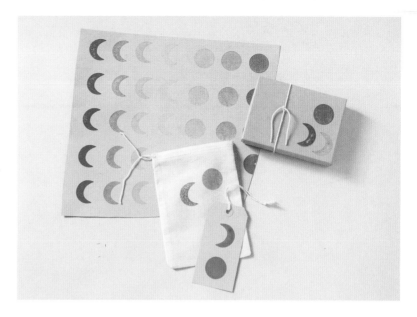

Other Ideas

Little stamped muslin bags make a cute, personalized sachet for jewelry or a fragrant potpourri pouch. Simply insert a piece of paper cut slightly smaller than the bag into the opening of the bag before you print (**A**); you'll prevent extra ink on the stamp from soaking through to the back of the bag. Let the bag dry completely before removing the inserted paper.

Small gift boxes without a glossy surface can be stamped too. Try taking the lid off and placing it on the back side of the box surface before you stamp. This will form a more stable surface to bear down on when you stamp. Just don't press too hard, or you will crush the box!

Stamped gift tags are a good way to add a personal note to any gift. When stuffed into an envelope they make a cute (and cheap) greeting card that the recipient can then hang in their house.

A

PiECE O' STRiNG DESK BLOTTER

The cool thing about being messy is that you find the greatest stuff when you clean. My biannual desk-drawer clean-out recently yielded a small block of wood, some half-used gum erasers, wine corks, and many other little items of indecipherable origin or use.

I wrapped twine around the wood block to make a stamp. I liked the design the impression from my new twine stamp created, but I knew that to appreciate the design, it would be best shown in repetition. And since my desk was clean anyway...

For this project I prefer watercolor board because it has a finer tooth, but canvas board is more widely available. Because canvas board usually comes with an acrylic gesso surface, do not use regular stamp pads—the ink won't stick. You can make your own studio ink pad though (page 30). For the corner borders here, I chose canvas paper because it matched the texture of the watercolor board, and it's strong without being too bulky to wrap around the corners.

INSTRUCTIONS

MAKE THE BLOTTER CORNERS
1. Apply one coat of ink to the canvas paper with a brush. When it's dry, apply one light coat of Mod Podge with your brush.

2. Cut both sheets into two 6" (15cm) squares using a craft knife and a straight-edge ruler. Fold the squares in half to form triangles **(A)**. Measure and mark a line ½" (13mm) in on both unfolded edges of each triangle **(B)** and fold them under; burnish with the bone folder and mark with a permanent marker.

MATERIALS

8 oz (226g) acrylic paint or screen printing ink
Two 9" x 12" (23cm x 30.5cm) sheets of canvas paper
5" (12.5cm) flat brush
Mod Podge
Craft knife
Straight-edge ruler or T-square.
Bone folder
Permanent marker
30" (76cm) length of kitchen twine
2" x 2" (5cm x 5cm) wood block.
Studio ink pad (page 30)
Newsprint or scrap paper
18" x 24" (45.5cm x 61cm) canvas board or watercolor board

FOLD IN HALF

A

TRIM 1"

½" ½"

B

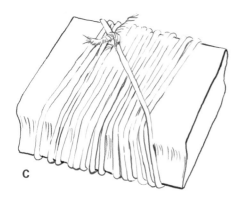

C

D

FOLD OVER CORNER

E

3. Clip the tip off the triangle where the two lines meet (**B**). Open up the triangle, apply a coat of Mod Podge, and refold. Remove excess Mod Podge with a damp cloth.

4. When dry, fold over the marked lines and burnish with a bone folder.

PRINT THE DESK BLOTTER

5. Coil the length of twine around the wood block and secure with a knot (**C**). Trim excess twine. Make sure the twine is in one layer, not crossing over itself. Adjust the angle of the twine lines if you want.

6. Press the stamp on the ink pad several times to get an even layer of ink on the twine's surface. Test the stamp on newsprint or scrap paper until you get an evenly inked impression.

7. Press the stamp into the ink pad, then press the stamp onto the board at the top left corner. Turn the stamp 90 degrees and press it onto the board at the right edge of the previous stamp. Turn the stamp 90 degrees and repeat until the board is completely printed (**D**).

8. When the ink is dry, apply a coat of Mod Podge and set aside to dry. For such a large area, I use ¼ cup (59ml) of Mod Podge and spread it evenly over the surface with a brush.

9. When Mod Podge is dry, lay a canvas paper triangle over the printed face of the board so the trimmed corner meets the corner of the board, and fold the scored edges over the sides (**E**). Coat the edge of the triangle with Mod Podge and set to dry.

10. Repeat with other 3 corners.

TROUBLESHOOTING

If you want a completely straight line, lay a T-square on your board to act as a guide. You may mark lightly with a pencil.

If the impression looks faint, add more ink to the stamp by pressing it multiple times on the pad.

If the impression is blurry, there is probably too much ink on the stamp. Press the stamp several times on scrap paper to remove excess paint and try again.

If the impression is uneven, you are probably not using consistent pressure. Just practice pushing down evenly on the scrap paper.

Other Ideas

My file folders were looking pretty drab next to my new blotter so I went back to the junk drawer for more found-object stamps. I used the same technique as above for all of these other ideas:

- Polka dots made with a rubber stopper
- Another string design made with a spindle wrapped with string. Slide a pencil through the spindle to roll.
- Brick design made with the side of gum eraser
- Triangle design made with a gum eraser cut in half

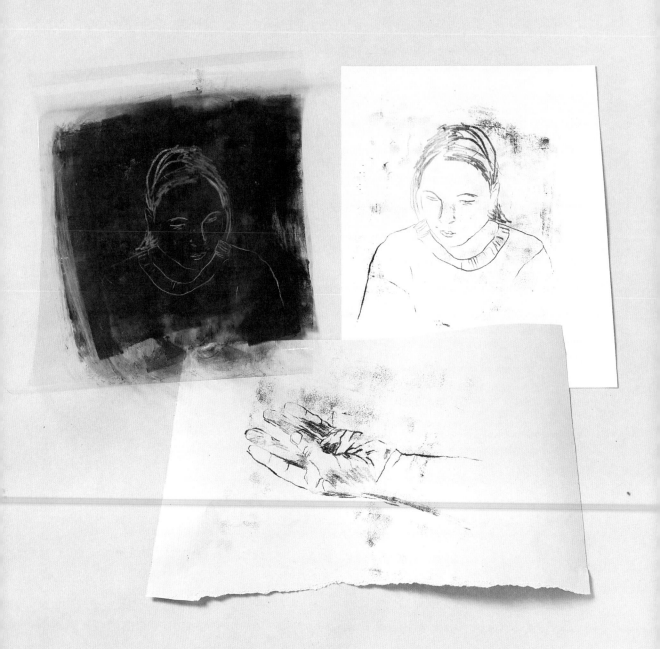

MONOPRINT

This project was inspired by the painter Paul Gauguin, who invented this technique of monoprinting by drawing onto an inked sheet of paper to transfer the image to another sheet of paper. Though it does not require a relief plate, monoprinting uses block printing ink and burnishing to create an image on paper so it's sort of like block printing without the block! It's also a quick and spontaneous way to make a series of prints.

This technique gets its name because each individual (mono) print will vary in appearance despite using the same photocopied template. I've found it's best to use loose or gestural drawings since the ink only has a limited amount of working time before it will dry on the paper. That may sound like a hindrance, but drawing and burnishing the image with vigor will translate into compositions with great dynamic movement. Experiment with different marks created with a pencil, pen, bone folder, and your fingers to vary the texture, tone, and line quality. Any type of paper will work here, but I personally like the soft surface of watercolor paper.

MATERIALS

Drafting tape
11" x 14" (28cm x 36cm) sheet of acetate, such as Mylar®
8" x 10" (20.5cm x 25.5cm) photocopy of your own artwork
11" x 14" (28cm x 35.5cm) piece of newsprint
Paint palette
Block printing ink
Brayer
Five 8" x 10" (20.5cm x 25.5cm) sheets of watercolor paper
Marking tools (pens, pencils, bone folder, etc.)

INSTRUCTIONS

1. Place a 10" (25.5cm) strip of tape on the left side of the acetate and secure it to a flat work surface. Tape the photocopy of the template image **(A)** faceup on the acetate and secure the four corners with 2" (5cm) strips of tape. Place newsprint under the acetate.

2. Flipover the acetate to the left of the flat work surface.

TEMPLATE

A

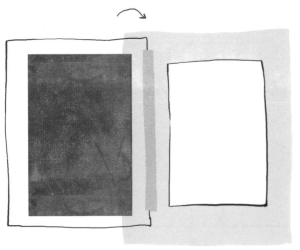

INK WITH BRAYER

B

3. Fill the paint palette with ink and, using the brayer, coat the opposite side of acetate with an even layer of block printing ink **(B)**.

4. Place the watercolor paper in the center of the newsprint sheet and turn the acetate over the watercolor paper. Trace the image with your choice of marking tools **(C)**. Only the inked areas that have been pressed will transfer to the paper.

5. Remove watercolor paper and set aside to dry.

6. Repeat steps 3–5 with the remaining sheets of watercolor paper **(D)**.

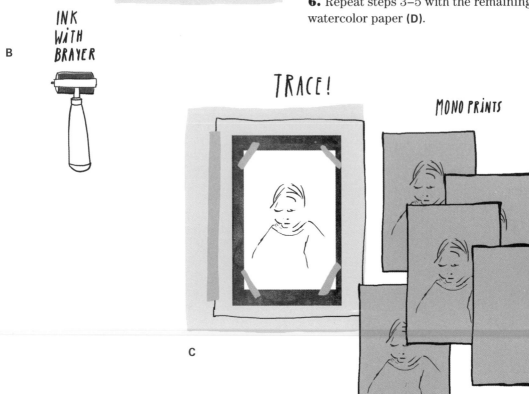

TRACE!

MONO PRINTS

C

D

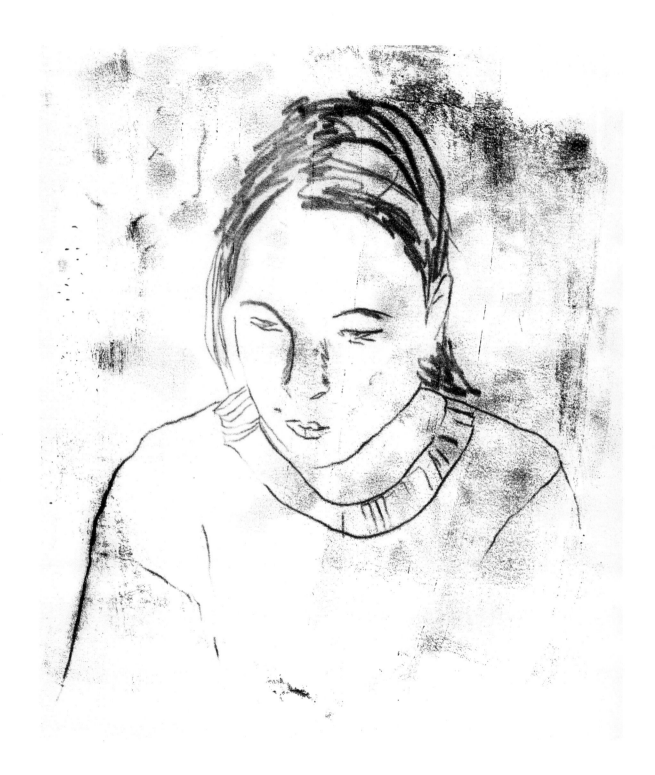

Relief Printing

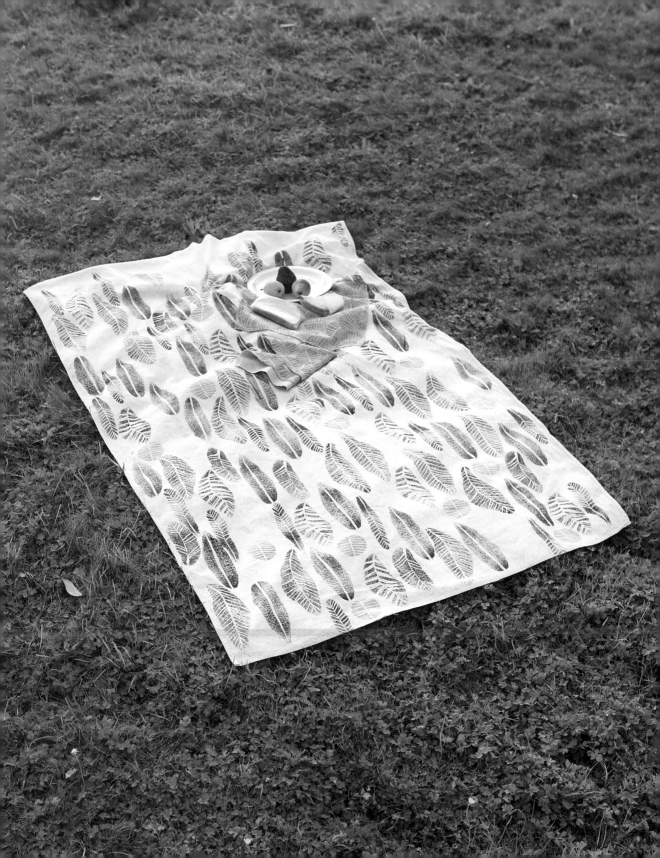

VEGGIE PICNIC SET

MATERIALS
4' x 15' (1.2m x 4.5m) canvas drop
 cloth with finished edges
Pinking shears
Large, old blanket (for a
 drop cloth)
Cutting board
Large kitchen knife
Assorted sizes of sweet and
 russet potatoes
Linoleum carving tool with
 U-gouge blade
Popsicle stick
Fabric screen printing ink
Paint palette
4" (10cm) foam brayer

After examining the gnarled contours of sweet potatoes
at the market, I knew I wanted to make a print that took
advantage of the variety of shapes. I used a couple types of
potatoes to achieve a fuller spectrum of shapes and sizes, and
I let the natural contours guide my linoleum cutter.

I chose a durable and inexpensive canvas cloth to make
this picnic blanket and napkins. I chose it for several
reasons: Its finished edges saved me time, and I wanted to
utilize the tooth of the canvas to provide interesting texture
to my print. And the price was so low that I could have
fun printing and not worry about ruining some expensive
blanket! Also, the massive size of the cloth allowed me to
cut off a large piece to be used for matching napkins and
a test piece of fabric to boot!

INSTRUCTIONS

1. Wash the drop cloth in warm water; dry and iron it.

2. Fold the drop cloth in half and cut along the fold with
pinking shears. Piece A will be the picnic blanket. From the
other piece cut four 20" (51cm) squares with the pinking
shears. Pieces B, C, D, and E will be used for the napkins;
the remaining piece F will be test fabric **(X)**.

3. Lay the old blanket on a flat work surface; a clean floor
works nicely.

4. On a cutting board, use the kitchen knife to split
the potatoes in half lengthwise with one swift motion
to create 2 oblong shapes.

CANVAS

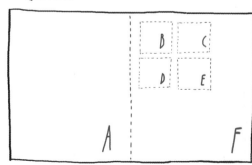

X

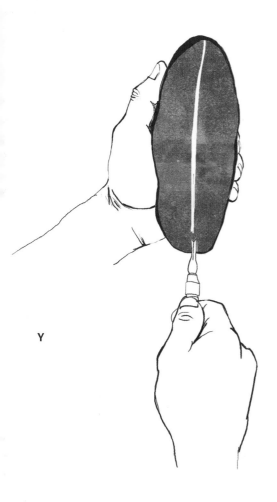

Y

5. Hold a potato half steady and carve (pushing the knife away from you) the midrib of a leaf as shown (**Y**). Carve veins of the leaf in assorted patterns (**Z**).

6. Repeat steps 4 and 5 for the other potato halves.

7. With a Popsicle stick, dab 2 spoonfuls of printing ink onto the palette. Run the foam roller through the ink and then pick up the brayer. Roll the brayer through the ink again and again until the foam roller is evenly saturated with ink.

8. Roll the ink firmly over a potato half, then press the potato firmly onto the test fabric. You can use both hands to press down on the potato if necessary.

9. Once you have a good sense of how to print with the potato, repeat step 8 with all your carved potatoes until you achieve a leaf-print design that covers the whole blanket as well as your napkins.

10. Heat-set the ink according to manufacturer's instructions.

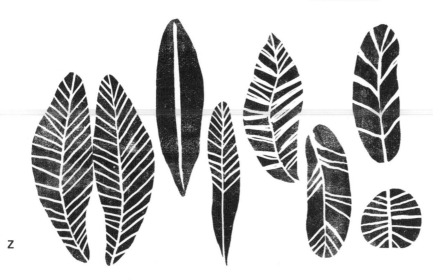

Z

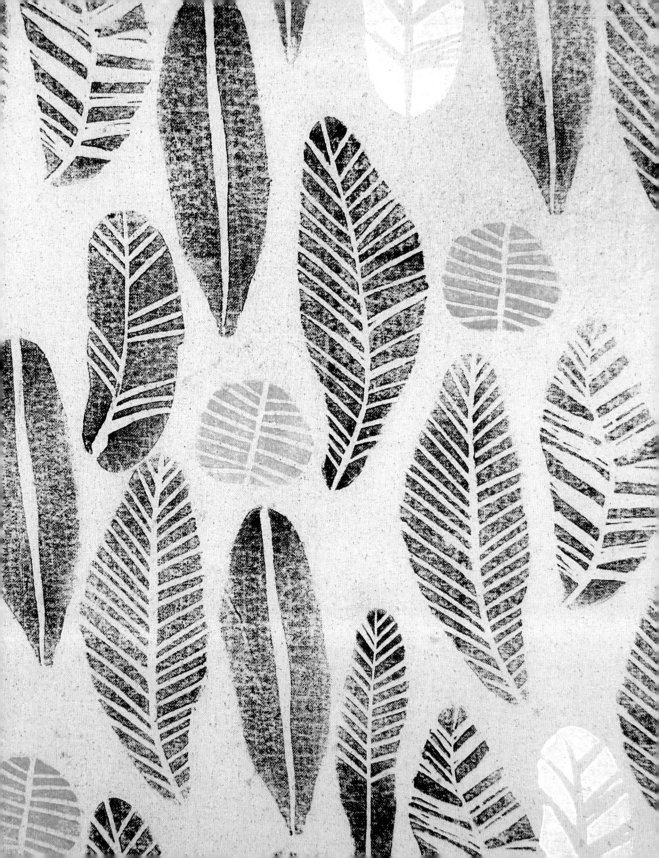

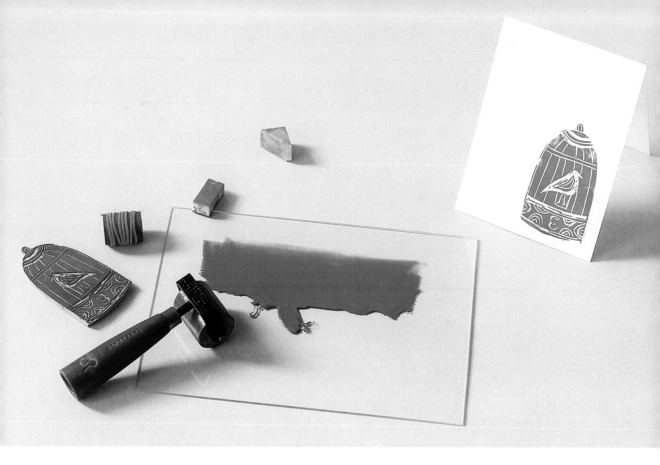

YOUR VERY OWN STATIONERY

This is pretty much my go-to gift for everybody, for every occasion. All the hallmarks of a good gift are here: It's personal, it's useful, it's versatile, and lucky for us, it's fun and fast to make. Blank stationery sets can be picked up at any stationery store—and there's no need to have the card match the envelope because sometimes the contrast can make it even better. If you are engraving your own design freehand, just remember to carve the text backwards.

MATERIALS

Template (page 156) or your own
 artwork
Pencil
5" x 5" (12.5cm x 12.5cm) Speed-
 ball Speedy Carve block
Bone folder
Linoleum carving tool with
 V-gouge blade
2.5 oz (70g) tube block
 printing ink
Paint palette
2" or 4" (5cm or 10cm) soft
 rubber brayer
Set of 25 blank stationery cards
 and envelopes

INSTRUCTIONS

1. Photocopy the template **(A)** or use your own artwork. Trace the black lines on the design with a pencil.

2. Turn the paper over so that the outlined design is facedown on the block and burnish with a bone folder. Holding the paper in place with one hand, carefully lift a corner of the page to make sure the image is transferring. The image and type on the finished print will appear in reverse on the block **(B)**.

3. Carve around the lines you transferred. If you are using your own design, remember that anywhere you carve will not print (in other words, the print is actually everything except what you are carving) **(C)**.

4. Squirt a spoonful of ink onto the palette and roll the brayer through it until it is coated evenly.

5. Use the brayer to lay a thin coat of ink on the surface of the block.

6. Being careful not to touch the surface of the inked block, press the block onto the stationery paper. You may want to use both hands and press down on the back side once you lay the block down.

7. Remove the block carefully and give the ink a chance to dry before you handle the print. Enjoy your prints **(D)**!

TEMPLATE
(INSERT YOUR INITIAL)

A

BLOCK

PRINT

REVERSE

B

C CARVED BLOCK

D

TROUBLESHOOTING

If you forget which part you're supposed to carve after you've made your outline, just look back at the template. Anyplace that's white is supposed to be carved.

Carve delicate curves by rotating the block instead of changing the angle of the tool.

If your tool is not engraving correctly, it might be dull. Replacement blades are available in small packs.

If your ink is drying too quickly, you can add a few drops of water to the ink plate and distribute it with the brayer.

Another Idea

Mount your carved block on wood with superglue **(E)** and present it with the custom stationery so in the future your recipient can make their own. Just make sure to clean it off first! Also, you might as well whip up some custom wax seals for the back of the envelopes. See page 53 for details.

E **MOUNTED BLOCK**

PRINTS = VIVA VARIETY !!!

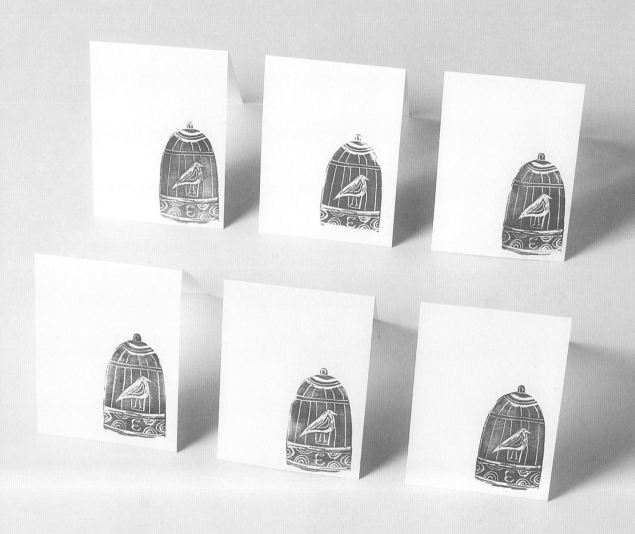

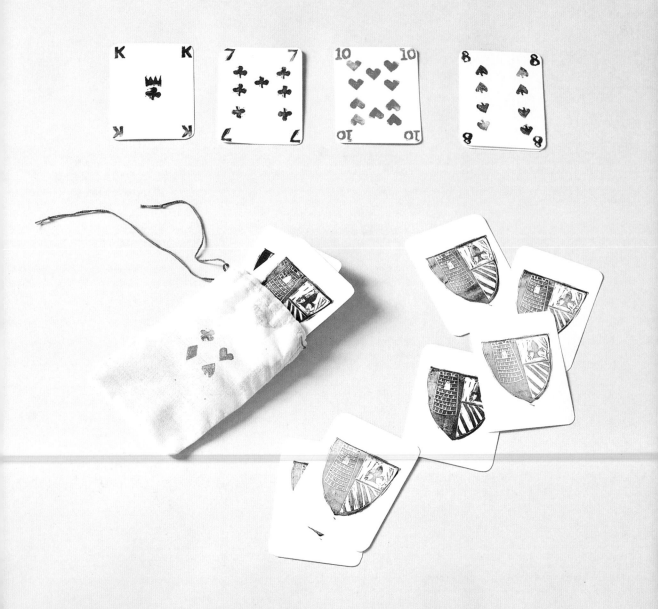

DECK OF CARDS

The draw of gambling eludes me. Losing real money just makes me sad, and even when I win I am not that happy; I am just placated by the idea that at least I didn't lose. But I do like all the stuff that comes with gambling. Multicolored chips with little intricate carved inscriptions. Card dealers with smooth, quick hand movements. The free drinks! And most important, the playing cards.

Almost every casino has its own set of house cards, but most of them probably don't know they're carrying on a very old tradition. Playing cards were one of the first things ever relief-printed for mass consumption. So join the proud tradition, and the Las Vegas casinos, with your very own house deck! I had a load of scrap paper handy so I cut the cards myself. You could also purchase place cards or other similarly sized flat cards from a stationery store for an easy head start.

INSTRUCTIONS

1. Photocopy the templates.

2. Use the pencil to trace the outlines of the shapes, letters, and numbers **(A)**. To prevent smudging, work from left to right (or vice versa if you're left-handed) and be careful not to place your hand over anything you've already traced.

3. Place the paper facedown on the block and rub the back of the page with your bone folder **(B)**. Holding the paper in place with one hand, carefully lift a corner of the page to make sure the image is transferring.

4. Place the linoleum carving tool between your thumb and index finger. Pushing the tool away from your body, carefully carve the outlines of your traced design **(C)**. Make sure you

MATERIALS
Pencil
Templates (page 157)
Two 3" x 5" (7.5cm x 12.5cm) Speedball Speedy Carve blocks
Bone folder
Linoleum carving tool with assorted blades
Two 2.5 oz (70g) tubes block printing ink, 1 black and 1 red
Paint palette
2" (5cm) brayer
Scrap paper
Sixty 2¾" x 3½" (7cm x 9cm) pieces of card stock (52 plus extras in case you make any mistakes!)
Dish soap
Corner punch or scissors (optional)

TRACE TEMPLATE

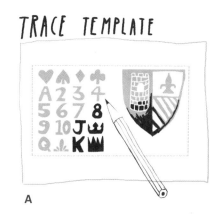

A

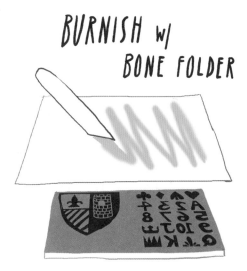

BURNISH w/ BONE FOLDER

B

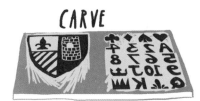

CARVE

C

carve only in the white space around the pencil lines! When the outline is finished, switch to the wider U-shaped blade to finish carving the negative spaces. Remember that the type on the stamp must appear in reverse in order to print correctly (D).

5. Squeeze out a nickel-sized amount of black ink onto your paint palette and roll the brayer through the ink to create a thin, even layer that measures about 4" x 6" (10cm x 15cm).

6. Grasp the top of the crest stamp with your thumb and index finger, press it into the ink, and then press the inked stamp onto some scrap paper using even pressure. Practice this step to make sure the design prints clearly.

7. Switch to the card stock and stamp the crest motif onto 60 cards. Be careful not to let anything come into contact with the stamped cards until the ink is completely dry. Repeat step 5 if the stamp starts to lose detail as you print.

8. Once all the sheets are dry, make 2 stacks, crest side down, of 26 sheets.

9. The first stack of 26 will be clubs and spades (which both use black ink). Using a craft knife, cut up the second block so that each letter, number, and symbol is its own stamp. Repeat Step 5.

10. Repeating Step 6 with each stamp, make 2 sets of 13 cards (2 through 10, Jack, Queen, King, and Ace), stamping one of each letter or number in the top and bottom corners of each card.

11. Stamp the appropriate number of clubs in the middle of one set of 13 cards. (Jack, Queen, and King would use one club in the middle with their respective crown printed over it; see template for reference).

12. For the second set of 13 cards, repeat step #11 with spades instead of clubs.

13. Thoroughly clean the stamps, palette, and brayer with warm water and dish soap. Dry all equipment thoroughly with a towel before proceeding.

14. Repeat step 5 with red ink.

15. Repeat steps 10–12 with the remaining stack of 26 cards, replacing clubs and spades with hearts and diamonds.

16. If you'd like smooth-edged cards, round the corners with a corner punch or scissors.

Other Ideas

The ace or queen of hearts would make a cute gift tag—just use a hole punch and some string to attach it to the perfect present.

Go beyond the provided template motifs and make up your own suits! Maybe the hearts, diamonds, clubs, and spades should really be acorns, birds, flowers, and bicycles or suns, moons, clouds, and rain. The possibilities are endless!

Print your own poker chips by stamping carved number stamps onto wooden nickels for a real homemade gambling experience.

Stamp your own muslin bag or box to hold your cards. See page 31 for details.

STAMPS

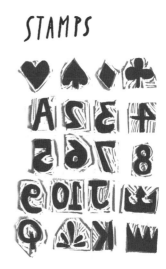

PRINTS

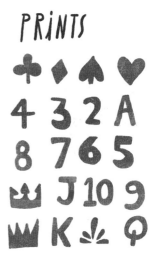

D

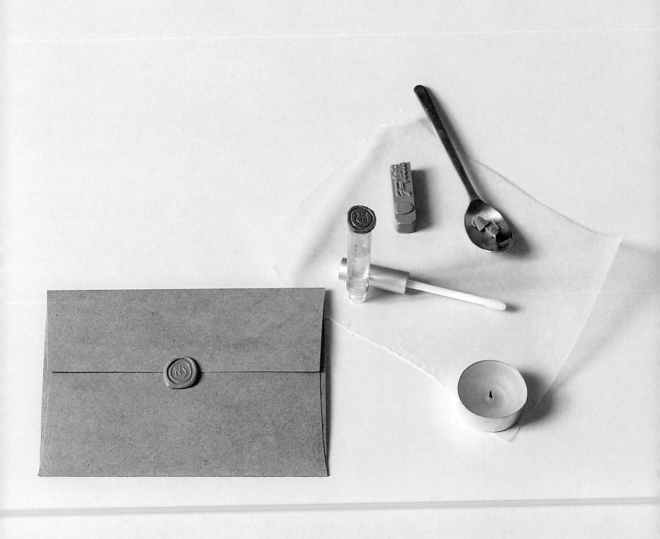

ROYAL WAX SEAL

I was a middle child with skinned knees and a general desire to make a mess; any attempt I made to play princess would have been met with eye rolls. But I still enjoyed making wax seals, which made it seem like each letter from my desk was some royal decree! Custom metal seal stamps are hard to come by, so now I make my own.

Once you've got your seal, why make just the one seal you need now? I make several wax seals at a time on a sheet of glue dots so I can pull them off and give a regal touch to any correspondence in a snap. If you want to go this route, try resting the stamp on an ice cube between impressions. It makes the rubber more rigid and cools the wax quickly.

Note: *Sealing waxes are now mixed with resins, making them more durable and less prone to cracking. Look for a wax stick marked "flexible" wax. Sealing waxes that heat in a glue gun are also available, but the colors are limited and they have a distinctly plastic look to them.*

Be aware that the U.S. Postal Service prohibits mailing wax seals as fixed to the exterior of envelopes. So if you plan on mailing your envelope, make sure to place it inside a larger envelope first.

MATERIALS
Sheet of paper
Pencil
2" x 2" (5cm x 5cm) piece of Speedball Speedy Carve blocks (I tried other linoleums, but the Speedy carve block won by a landslide)
Bone folder (optional)
Linoleum carving tool
Superglue
Tube of clear lip gloss with wand
1 roll or sheet of glue dots (see Tip, page 55)
Craft knife
Sealing wax stick (see Note)
Small spoon
Votive candle

INSTRUCTIONS

MAKE THE SEAL
1. Create a template by drawing your design on a sheet of paper with a pencil **(A)**; a simple graphic about ¾" (2cm) or smaller works best.

2. Turn the paper over and rub the design onto the block with a bone folder or your thumbnail. When the image has transferred it will appear in reverse.

TEMPLATE

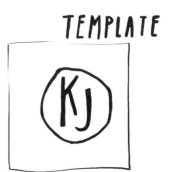

A

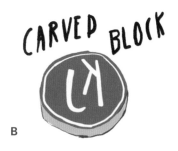

CARVED BLOCK

B

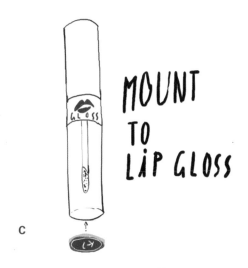

MOUNT TO LIP GLOSS

C

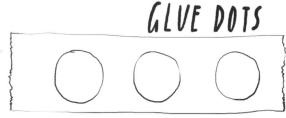

GLUE DOTS

D

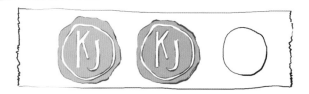

E

3. Since you want the wax to fill in where the letters are, carefully carve out the pencil lines—not around them this time. Hold the carving tool as you would a paring knife and carve around the design. You can make the stamp itself a square or a circle **(B)**.

4. Turn the carved face of the block facedown and attach the back side with glue to the bottom of a lip-gloss tube **(C)**. Set aside to dry.

MAKE A SHEET OF SEALS

5. Place the sheet of glue dots on a flat work surface **(D)**.

6. Slice several small pieces off the wax stick with a craft knife. Place one slice in the spoon and set the rest aside.

7. Place the spoon over the edge of the lit votive candle to melt the wax. Make sure the flame only makes contact with the bottom of the spoon—not the wax—because most sealing wax is flammable and turns black if burned.

8. Remove the spoon and drip the molten wax over the first glue dot.

9. Lubricate the face of your stamp with the lip-gloss wand and press the stamp into the molten wax. Do not press all the way down to the glue dot.

10. When you see the wax start to harden around your stamp, gently peel away the stamp to reveal the design **(E)**. It will take a few wrecked seals to get the exact timing and pressure needed to create a good seal, but you will be making dozens of these in no time.

Choose the right glue dot for your project; they are sold according to size and level of adhesion. Use low or medium tack for sealing envelopes. If you want the position of the seal to be permanent, choose a glue dot with high tack.

Other Ideas

Have some homemade vinegars or oils in bottles on your table? Give them a professional finish with a wax seal. Just dab the back of the glue dot with superglue for durability. Add wax seals to your wedding invitations for an old-world feel. Try using the first letters from your given names. After the wedding you could add your new monogram to your seal for the thank-you notes.

Use your carved seal as a regular stamp to "sign" an edition of prints (page 22).

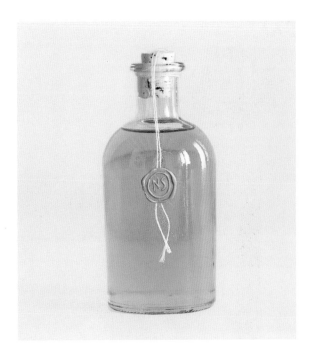

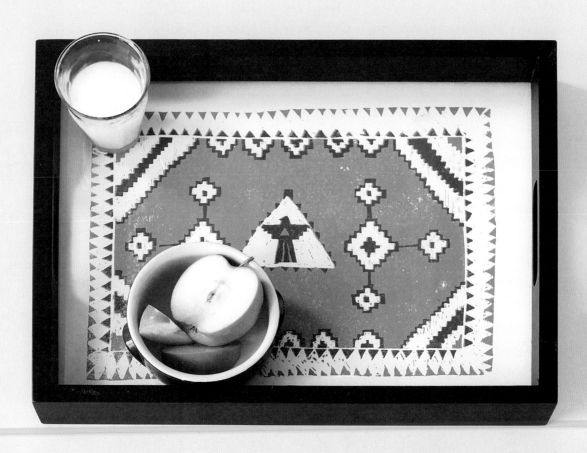

REDUCTiON PRiNT PiCTURE TRAY

Reduction prints take some practice and planning: You carve the block and print with a light color. Then you carve more away from the block, lay the paper down in exactly the same position, and print with a darker color. The darker color covers parts of the lighter-color print. Further complicating things is the fact that there are no "do-overs." Once you have done the second carving of the block, the first carving is gone for good. But despite the increased effort, the results are worth it! To avoid registration disappointment, just make more prints than you need so that each one isn't as precious. I also find that it's best to use a design that can still look cool even if it's not registered exactly.

INSTRUCTIONS

FIRST CARVING

1. First, carve the registration marks. With the ruler, mark a line that is 1" in from both the bottom and right side of the block. Use a craft knife to make a ⅛" (3mm) wide score along these lines **(A)**.

2. Photocopy the template, enlarging 230%, onto four 8½" x 11" (21.5cm x 28cm) sheets of paper. Cut away the extra paper and tape the seams of the templates together. Trace the design lines with a pencil, filling in part A with solid pencil **(B)**.

3. Turn the paper over so the design is facing down and align it to the top left corner of the block. Burnish to transfer the image.

4. With the carving tool, use a small V-gouge blade to outline the design and a larger U-gouge blade to clear out areas around the design (up to the registration marks).

MATERIALS
Straight-edge ruler
12" x 18" (30.5cm x 45.5cm) mounted linoleum block
Craft knife
Templates (page 158)
Scissors
Drafting tape
Soft pencil
Linoleum carving tool with assorted blades
Two 5 oz (140g) tubes of ink, one light and one dark color
Paint palette
Brayer
Fifteen 16" x 20" (40.5cm x 51cm) sheets of hosho paper
Barren
Pushpins
Large cutting mat, at least 2" (5cm) larger than print paper
16¾" x 12½" x 2" (42.5cm x 32cm x 5cm) picture tray

A

B

FIRST CARVING

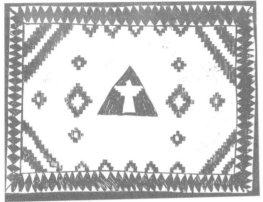

FIRST PRINT

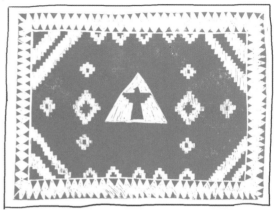

SECOND CARVING

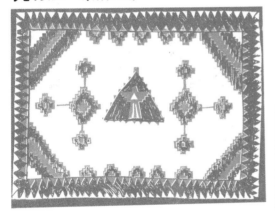

SECOND PRINT

ALIGN RIGHT
ALIGN BOTTOM

c

5. Squeeze a spoonful of the lighter-colored ink onto the paint palette and roll the brayer through the ink until it is evenly coated.

6. Roll the brayer over the block, leaving the registration marks uninked.

7. Hold a sheet of paper in your right hand and align the right corner with the right registration marks. Align the left corner of the paper with the registration marks **(C)**.

8. Burnish with the barren.

9. Repeat steps 6–8 with the remaining 14 sheets, adding ink to the palette as needed.

10. Clean the brayer and palette.

SECOND CARVING
11. Place the template over the block again and with a pushpin mark all the shapes to be carved out. You will be carving out more of the design.

12. Carve the outlines with a V-gouge and the larger area with U-gouge blades.

13. Squeeze a spoonful of darker ink onto the palette and load the brayer.

14. Roll the brayer over the block, leaving the registration marks uninked.

15. Holding a sheet of printed paper in your right hand, align the bottom right corner and then the left bottom edge with registration marks and burnish with the barren **(C)**.

16. Repeat with the remaining 14 sheets, adding ink to the palette as needed.

17. Let prints dry overnight.

18. Sign and number your prints.

Framing the Print

Custom framing is great if you have the time and resources. But I am cheap, and when the print is done I want it framed yesterday. Ready-made frames with precut mats come in only a few select sizes, so I buy a ready-made frame, ditch the precut mat, and use the sheet of glass as my cutting template (that way I know exactly how the print will look in the frame). The only key thing to remember is to hold the blade of the craft knife at a 45-degree angle to the glass so you cut the paper just a hair smaller than the glass sheet. Look for a frame with UV-resistant glass (to preserve your print) and avoid frames with clear acrylic panes because they scratch too easily.

MATERIALS
Print on paper slightly larger
 than art area of frame
Cutting mat
Ready-made frame
Straight-edge ruler
Craft knife

INSTRUCTIONS
1. Place the print on the cutting mat.

2. Center the sheet of glass over the print and check the alignment with a ruler. Tilt the craft-knife blade at a 45-degree angle and slowly cut the print along the edges of the glass.

3. Insert the print and glass into the frame and secure according to manufacturer's instructions.

STENCIL PRINTING

Power can be used for good or for evil. The viral insurgence of kitschy country stencils in 1980s home decor is proof of this. For all its pastels and folksiness, it secretly used the power of the stencil for evil. Breakfast nooks were soon overtaken by garish flat ivy patterns. Bathrooms succumbed to an army of geese wearing ribbons for scarves. If this is your experience with stencils, I'm here to tell you it's ok. Shhh. They're gone. Those geese can't get you anymore. We're going to use stencils to create good designs.

We're not the only ones either. Many talented artists have started using stencils in the past two decades. The contemporary artists Shepard Fairey and Banksy use stencils to create striking visuals with strong social commentary. But even long before their time, artists like Matisse used stencils, called *pochoir* in French, to create brilliantly colored prints. The relevance of stenciling remains strong because of its versatility on different materials and its ease of use.

Stencils are physical negatives that are used as a template to paint identical images or shapes. Stencils are either negative shapes made of masking film or positive shapes cut out or built up by masking film. Ink or paint is applied by stippling brush, paintbrush, or foam brayer, and the stencil retains the ink, leaving only the inked design on the surface. The method of stenciling is determined by the image you want to print and the materials, or substrate, you want to print on.

TOOLS AND MATERIALS

TYPES OF STENCILS

Acetate (Mylar) stencils: This material is sold in a variety of thicknesses; use 0.005" to 0.010" acetate. Thin sheets will tear easily but are easier to cut than the thicker sheets. Because this film is clear, you can lay your design underneath to cut it out. Mylar is just a brand name; the generic term is actually "plastic film" or "plastic sheet." Acetate is common version of a plastic sheet made with cellulose acetate.

Contact paper stencil: These self-adhesive shelf liners are great for stenciling on just about anything but paper (because the adhesive will stick too strongly to paper). Because the film stretches a little, be very careful when applying and removing the stencil. Also, the adhesion degrades after it is pulled off, so this is usually good for only one or two uses.

Frisket film: This film comes in a roll and looks just like contact paper. Its adhesive is specially formulated to pull easily away from watercolor paper. It is clear but shiny, so you can see where you have covered.

Masking fluid stencil: Masking fluid made of liquid rubber latex can be painted with a brush to areas where you don't want to print. The fluid dries to create a stencil film directly on the paper. The masking fluid, such as the one made by Winsor & Newton, is lightly pigmented so you can see where you have applied it. This technique is awesome for creating fine lines. Your surface can be masked several times; just make sure it's dry before you start the next coat. And I don't care what that bottle says—even after prompt cleaning with warm water and soap that brush will never be the same, so designate one just for this purpose.

Oil board stencil: Available in large sheets, this coated card stock is challenging to cut with a craft knife and is not good for fine detail. However, it is so sturdy you can use it many times before it starts breaking down. Unlike acetate stencils, you can't see through it, so it's best for one-color jobs. You can also make your own oil board by painting a side of card stock with a matte medium like Mod Podge. Coated file folders can also work in a pinch.

SURFACES

Wood: Stenciling is a good way to personalize wood boxes, plaques, furniture, and even floors. For a single shape I would use contact paper on wood because it will stay in place. If you want to repeat one shape over and over again go for acetate or oil board stencils. Always prepare your wood by sanding it down to a smooth, even surface with sandpaper before printing.

Paper: The sky is nearly the limit here: You can generally stencil on any noncoated paper. For stenciling on paper you should usually use frisket, which is basically a type of contact paper specially formulated to pull away from paper. It can be repositioned and used again and again. Masking fluid is good too, especially if you want to create one singular design with fine line quality on the page. Acrylic and watercolor paints will work here.

Fabric: For shapes with simple lines and not a lot of detail, I go with contact paper when I print on fabric. Although the stencil can be used again and is repositionable, the contact paper will stretch a little when you pull it off the fabric. You can also use an oil board stencil if you spray it with Sulky® KK 2000™ Temporary Spray Adhesive. Textile screen printing ink, with its perfect viscosity and bright colors, is ideal. Acrylic paint mixed with fabric medium will also work, but test it first on your fabric. If the paint it too thin, it will run; if it

is too thick, it will add a bumpy texture that you might not want.

INKS

Most projects in this chapter are made with acrylic paints. Liquid acrylics purchased from the craft store are generally fine, but if you are buying acrylics at the art store, where there is a larger selection, look for acrylic paint with "medium viscosity." If the particular color you want is available only in a tube, you can thin it out with water. Screen printing and textile screen printing ink can be used as well, though depending on the brand it may also need to be thinned with a few drops of water. Watercolor and gouache paint can be used for any frisket or masking fluid project. Latex paint can be used for some of these projects—see the project on page 83 for more information on buying latex paint.

1. Acrylic paint
2. Latex paint
3. Masking fluid
4. Watercolor paint
5. Gouache paint
6. Fabric screen printing ink
7. Fabric medium
8. Paint brushes and brayers

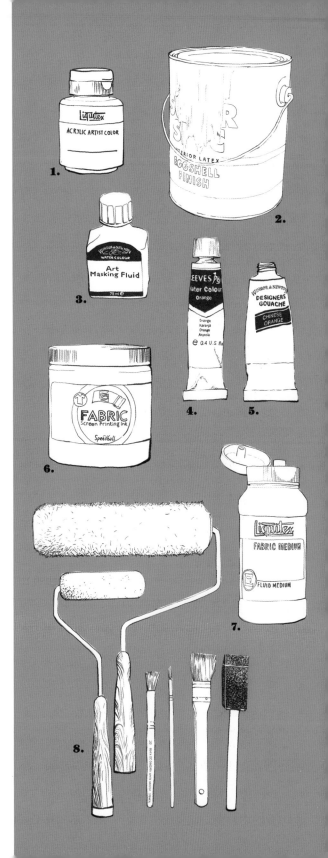

PRIMARY COLORS BOOK COVER

One advantage stenciling has over block printing is that you can see exactly where you are printing. I often use this to my advantage and layer stencils to create overlapping shapes in different colors. In this project I use the same stencil three times to make new colors out thin layers of the primaries.

MATERIALS
6" (15cm) square of paper.
Cutting mat
Craft knife
6" (15cm) square of acetate (Mylar)
Book with cloth or paper cover
Three 2 oz (59ml) tubes of liquid acrylic paint: red, yellow, and blue
Paint palette
Stippling brush
Paper towels

INSTRUCTIONS

1. Draw a 2" (5 cm) circle on a sheet of paper and place it on the cutting mat. Use it as a guide to cut a circle stencil out of the center of the acetate (A). Position the stencil on the book cover.

2. Squirt a teaspoon (5ml) of blue paint onto the palette and press the tip of the stippling brush into the paint. Dab the extra paint on a paper towel, and then press the brush onto the stencil. Move your hand up and down and reload the stippling brush as needed until the circle is full. Set aside to dry for about 15 minutes; clean the brush.

3. Place the stencil on the book cover, overlapping the blue circle, and load the stippling brush with red ink. Paint (B).

4. Repeat with yellow, overlapping both circles as shown on the cover.

TROUBLESHOOTING
If the ink bleeds under the stencil, there is too much ink loaded onto the stippling brush or the stencil moved when the paint was being applied.

If the ink peels off when stenciling over area that has already been stenciled, the first coat of ink probably is not dry. Fill in peeled area with a detail brush.

TIP
When overlapping with a paint that is not opaque, always work from the darkest color or shade to the lightest color or tint. Lighter colors will be overwhelmed by the strength of the darker color.

STENCIL

A

B

MiSS MANNERS PLACEMAT

As anybody with siblings knows, the division of labor is key to survival. When I was growing up, setting the table exempted me from dish duty, so I would create elaborate settings knowing that I wouldn't have to wash any of it. The habit is hard to break, and today in my house even takeout meals get a place setting. Plastic fork on the left!

The only tricky thing in this project is smoothing the edges of the contact paper so it is flush with the fabric. A pillowcase laid over the stencil and a low, dry iron heat the paper just enough so it is easy to burnish. If you are making several placemats, cut the appropriate number of pieces of contact paper first and trace them one after the other.

INSTRUCTIONS

1. Draw or print the template on two 8½" x 11" (21.5cm x 28cm) sheets of paper and tape them together (A). Tape the sheets to a sunlit window and secure each corner with a small piece of drafting tape.

2. Cut a piece of contact paper to the exact size of your placemat. Tape the contact paper over the template with the adhesive side facing the windowpane. Trace the design with permanent marker.

3. Remove the contact paper from the window and secure it to all four corners of the cutting mat with drafting tape. Carefully cut out the design with the craft knife, rotating the cutting mat to make circular shapes. Discard cutout shapes (B).

4. Lay the contact paper over the placemat so that the utensil handles are facing away from you. Peel the top 2" (5cm) of contact paper away from the backing paper and press it onto the placemat. Continue peeling away the backing and adhering the paper to the

MATERIALS

Template (you can draw one freehand—simply trace the outline of your utensils onto paper—or create one digitally with photo editing software)
Scotch tape
Drafting tape
Clear matte contact paper, at least 12" x 18" (30.5cm x 45.5cm)
Permanent marker
Cutting mat
Craft knife
12" x 18" (30.5cm x 45.5cm) ironed washable cotton or linen placemat
Pillowcase or other piece of cloth
Iron
Acrylic screen printing ink or textile paint
Paint palette
4" (10cm) high-density foam brayer

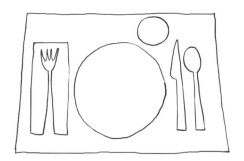

A

TEMPLATE

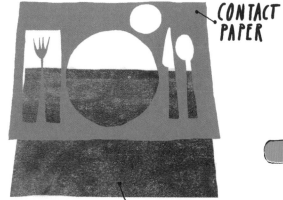

B

CONTACT PAPER

PLACE MAT

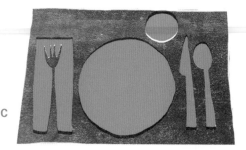

C

PRINT

FOAM BRAYER

placement, working your way down slowly and trying not to pull or warp the contact paper. Smooth the contact paper down with your fingertips, paying special attention to the edges.

5. Place a pillowcase or piece of fabric over the placemat and iron with a low, dry setting. This will gently heat the contact paper and smooth any ridges.

6. Put ¼ cup (59ml) of ink or paint onto the palette. Roll the foam brayer through ink, then pick up and repeat until the roller has an even coat of ink.

7. Apply the ink evenly to the cutout areas. (**C**).

8. When the ink is dry, remove the contact paper and heat-set the ink according to manufacturer's instructions.

SiMPLE SiLHOUETTES

Before photography was widely available, silhouette portraits were a quick and inexpensive way to get your headshot. Ornate profiles in black paper were the party trick of eighteenth-century Europe. At grand balls trained artists would carefully capture the contours of aristocrats in their towering wigs by tracing their shadow onto paper and cutting it out.

In this project we use photography, which ironically made the "shadow pictures" obsolete, to create our own stenciled silhouettes with contact paper. If you are doing a portrait consider keeping in a collar of a shirt and accentuating the curls of eyelashes and hair to give the outline a little more personality, but be true to the facial features to maintain likeness.

MATERIALS

Digital image printed to desired size or template (page 159)

Contact paper

Mod Podge

Scissors or cutting mat and craft knife

Flat brush or foam roller

Liquid acrylic paint

INSTRUCTIONS

1. Take a photo of yourself in profile, or of any object with an interesting shape, and print it out (**A**). Cut a piece of contact paper the same size as the paper with the digital image.

2. Use Mod Podge to paste the paper with the image to the matte side of the contact paper.

3. Weight the glued papers with a book or heavy, flat object and set to dry for 2 hours.

4. Using scissors or a craft knife, cut around the outline of the image. For a finished product in which the central image is painted (a "positive"), cut out the image only. For a finished product in which the central image is the negative space within a painted-on border (a "negative"), cut out everything except the image (**B**).

5. Peel the contact paper from the adhesive sheet and place the stencil on the surface to be decorated.

6. Apply ink with a flat brush for small objects or foam roller for a substrate that is larger than your hand.

7. When paint is dry, peel the stencil away from the substrate.

PHOTOCOPY

A

POSITIVE

B

NEGATIVE

Another Idea
Use the cutout silhouette shapes as temporary wall decals. Contact paper is available in many colors and patterns.

SHiP-SHAPE WALL ART

The bay view from my apartment in San Francisco is best experienced at dawn and dusk. The sunlight erases the horizon line, merging water and sky into one plate of color, and suspends the tiny ships in foggy gray space over the coastline. I'm from Kansas City originally, and the sight still floors me. For this project, I wanted to build a ship out of lines and create a gradient pattern to simulate the seascape that opens and closes my days. The fine contours made with a small round brush and masking fluid did the trick. A watercolor wash creates a contrasting ground.

MATERIALS
Template (page 160) or artwork
 of your choice
Drafting tape
9" x 12" (22.86 cm x 30.48cm)
 watercolor paper, slightly
 larger than design
Pencil
Masking fluid
2 paint brushes, 1 fine and,
 1 larger
Paint palette or paper plate
Watercolor paint or India ink
Gum eraser

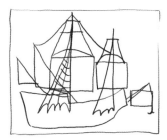

TRACED TEMPLATE

A

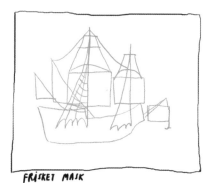

FRISKET MASK

B

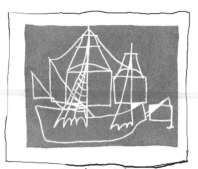

AFTER PAINTING + FRISKET REMOVED

C

INSTRUCTIONS

1. Print the design template or create your own artwork. Secure the print to a clean sunlit window with two small pieces of drafting tape at each top corner. Place watercolor paper over the design, securing it with drafting tape if necessary, and trace the design very lightly with pencil (A). Remove the watercolor paper from the window and gently peel away the drafting tape. Place the watercolor paper on a clean, flat work surface.

2. Shake the masking fluid well. Dip a fine brush into the fluid and apply over the traced lines (B). Don't worry about trying to get the same thickness of line—the variety in line quality will be more interesting. Allow masking fluid to dry completely.

3. Use the palette to dilute the paint or ink if desired, and apply it with the larger brush over the design in any fashion.

4. When the print is completely dry, gently rub or peel the dried masking fluid off the paper with your finger (C). I try to pull it off the paper in one piece—it's like removing an amazing piece of lace.

5. Remove traced pencil marks with a gum eraser.

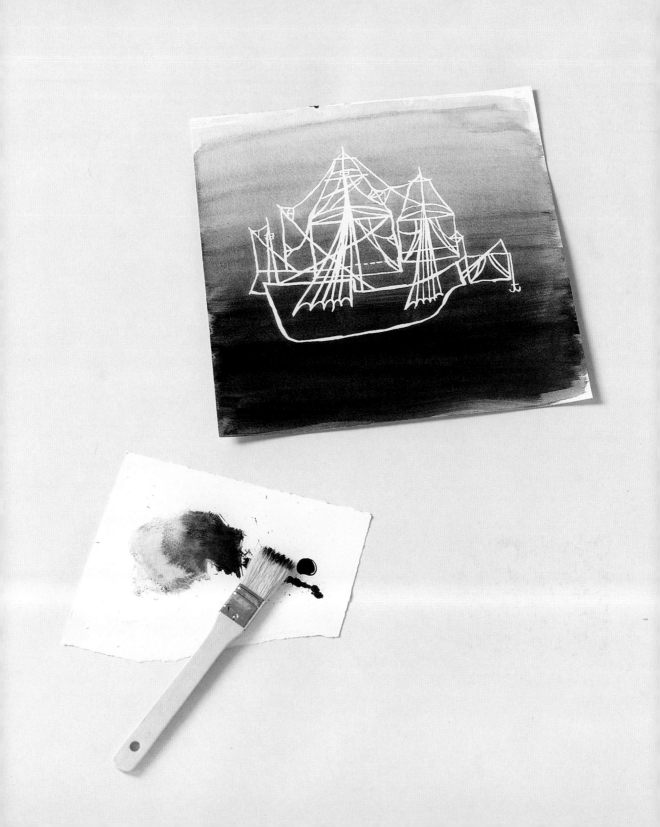

DRY BRUSH

DRY BRUSH STIPPLE

WET ON WET

ON FULLY SOAKED PAPER

WET ON WET

ON DAMP PAPER

WASH

SPONGE

Watercolor Crash Course

It's a shame that people stop playing with watercolors once they graduate from coloring books, because this paint is flexible, forgiving, and full of possibilities. Manipulating watercolor paint can provide many cool effects. Have some fun working with these different applications on a piece of scrap paper before deciding on one.

DRY BRUSH

Slightly moisten a brush, then dip it in watercolor paint for bright colors and precise brushstrokes. You can also stipple with a stiff stencil brush.

WASH

Use watercolor paint diluted in water to make soft pastels or other light colors. Let paint dry and paint with another layer of wash to create a new color.

WET ON WET

Dip a large paintbrush in water and coat the paper, then dab it in the watercolor paint and paint the paper.

SPONGE

After using the wet on wet technique, dab with paper towel or tissue to create a textures effect.

eux
autres

TONIGHT
BOTTOM OF THE HILL/8PM
W/ KELLIE GEM + STILL FLYIN'
1010 ALABAMA STREET
ADMISSION: 15 DOLLARS

SiLKSCREENED BAND MERCH

Bands, just like small businesses, need brand recognition. Despite my lack of musical talent, I have the good fortune to be friends with some amazing musicians. And even though their skills are boundless, their pockets aren't. I made these for my pals Nick, Heather, and Yoshi of the band Eux Autres. This low-detail alphabet can also be used to spell team names, events, or personal sayings. It might seem wasteful to remove the canvas to get to the frames in this project, but they are often sold in packs of two for under ten bucks and can be reused many times. I've seen the same method done with embroidery hoops, but this option provides better screen tension, which is good because we don't want the screen moving around while printing. The extra space around the design gives you working room for the brayer. Since the design has two colors and we need to separate them, each layer is on one screen.

INSTRUCTIONS

1. Copy your own design (or create a design using the template on page 161) onto an 11" x 17" (28cm x 43cm) sheet of paper (A) and secure it right-side up to the work surface with drafting tape.

2. Lay 1 polyester sheet over the template and secure it at the four corners with drafting tape. You will be able to see the design through the polyester.

3. Use a permanent marker to trace the "A" portions of the design, remove the fabric, and set aside. Tape the other polyester sheet over the template and trace the "B" portions of the design with the permanent marker (B).

MATERIALS
Template
Drafting tape
Two 13" x 16" (33cm x 40.5cm) sheets of white polyester organza fabric (make sure you get polyester—not nylon—organza, because nylon will stretch)
Permanent marker
Screwdriver
9" x 12" (23cm x 30.5cm) stretched art canvas
Staple gun with 1/4" (6mm) staples
Assorted paintbrushes
Mod Podge
Strong packing tape
10 same-size T-shirts (washed and ironed)
8" x 10" (20.5cm x 25.5cm) sheets of chipboard
2 colors textile silkscreen ink
Paint palette
4" (10cm) high-density foam brayer, stencil brush, or foam brush

DESIGN

A

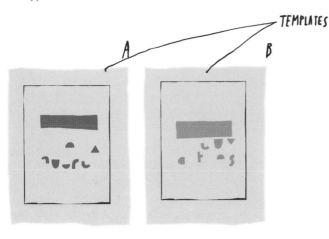

TEMPLATES

A B

B

C

D

4. Use a screwdriver to remove the staples holding the canvas to the frame. Reserve the canvas for another use.

5. Place the A fabric over the frame, fold the excess over the edge (C), and staple every inch along one side. Turn the frame 180 degrees. Pulling the fabric over the edge to make a taut fabric surface, staple every inch along the opposite side.

6. Turn the frame and repeat with the other two sides. The fabric should be taut against the frame like a drum (D).

7. With a thin flat brush, apply Mod Podge around the outlines of the design (E), and then fill in the small spaces. With a larger brush, fill in the area between the design and the interior line of the frame. Remove the fabric from the frame.

8. Repeat steps 5–7 with the B fabric, filling in the area around the design.

9. Set aside to dry for 24 hours. You can speed up the process with a hair dryer, but make sure you don't get the fabric too hot—it can melt!

10. Hold the painted screens up to the light. If you see many holes that aren't filled with Mod Podge, fill them in and set to dry.

11. Apply a strip of packing tape around the interior frame. Working outward, apply more strips until the tape covers the entire front of the frame.

12. Lay a T-shirt on the work surface and place a sheet of chipboard between the T-shirt's front and back.

13. Place frame A on the T-shirt where you want to print (E).

14. Tear two 5" (12.5cm) pieces of drafting tape and place on the T-shirt right along top left corner of the frame. This will help you register frame B for the next layer.

15. Place ¼ cup (59ml) of the first color of ink on the palette and roll the foam brayer through it. Pick up the brayer and roll through again, repeating until there is an even layer of ink on the roller. The brayer should be moist with absorbed ink but not dripping.

16. Holding the top left corner of the frame with your left hand, roll ink over the design (F).

17. Carefully lift the frame straight up from the T-shirt and set it aside to dry. Make sure the chipboard is left under the inked area while drying to prevent bleeding.

18. Repeat with remaining shirts and set them aside to dry, leaving tape intact.

19. Lay a dry T-shirt on the work surface. Align frame B with the drafting tape registration marks and repeat steps 16–18 (G).

20. Heat-set the textile ink according to manufacturer's instructions.

Other Ideas

Print a poster for an event on nice heavy paper. Thin paper will warp with moisture from the paint.

Print a 7-inch record cover for your band or a CD cover for a compilation CD.

E

F

G

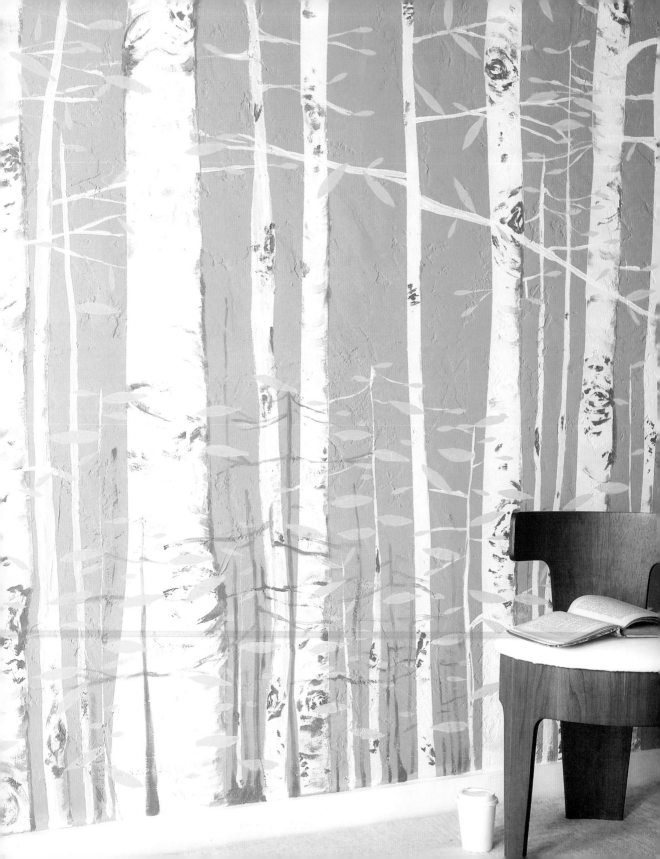

ASPEN TREE FOREST MURAL

The most important trick with mural painting is to work with the entire surface at once. Chances are you'll begin the day with vigorous brushstrokes and end the day with softer (and probably sloppier) strokes, so if you focus on one area and then move to the next as the day goes on, the results will be uneven. Step back and review the whole work and move to a different place.

I wanted to create a forest scene because it is easier to make a design that uses organic shapes—just like in nature, any imperfections provide interest to our eyes. An experienced painter could use this basic design and make it photo-realistic with precise shading, but I wanted to leave it so we could see the simple forms that create the composition.

INSTRUCTIONS

1. Prepare the wall and baseboards by wiping them down with a wet cloth to remove dust and debris. If necessary, fill in holes with spackling compound and sand to a smooth surface.

2. Place painter's tape on the baseboard where it meets the wall to protect it from paint drips. Lay down a drop cloth.

APPLY THE BASE COAT
3. Fill the paint tray with 1" (2.5cm) of gold base coat.

4. Use a foam brush to paint the corners and edges.

5. Load the large roller with paint and, starting about 12" (30.5cm) above the baseboards, roll paint onto the wall with light pressure and at a slight angle. Turn your hand slightly and come down with another long motion, loading the roller with paint as needed. If you get tired, wrap the roller sleeve in some plastic wrap or aluminum

MATERIALS
Ladder
2" (5cm) wide blue painter's tape
Drop cloth
Paint trays
Latex paint: 1 qt (0.95l) each in gold (for base coat), white, and bright yellow
Assorted foam and stencil brushes
3 rollers with foam sleeves: one 9" (23cm) and two 4" (10cm)
Plastic wrap or aluminum foil
Plastic containers or jars
Black liquid acrylic ink
Popsicle sticks
Paint palette
Oil board stencil film
Template

How Much Paint Should You Buy?

When trying to figure out how much paint you need for the base coat of any project, measure the length and width of the wall and multiply the dimensions. For the base coat, a gallon of house paint should cover approximately 300–450 square feet (20–42 square meters); the paint can's label will give you a better approximation. One quart covers 90 square feet (27.5 square meters). If you're painting on drywall or wood panel (like a folding door), which are absorbent, or if you're covering a dark color, you will also need to apply a primer coat.

foil so it doesn't dry out, and take a break. Let the paint dry for at least 4 hours.

6. Apply a second coat if necessary and let dry for at least 4 hours.

PAINT THE TREE TRUNKS

7. Standing on a ladder, press the end of the painter's tape to the top of the wall where you want to paint a tree, unroll it a bit, and then let the tape fall. As you step down the ladder, smooth the tape with your hands until the tape reaches the masked baseboard. Trees are not always perfectly straight, so go with it. Curve the tape to make a slightly contoured line. Tear the tape off from the roll when you hit the taped baseboard.

8. Go to the top of the ladder again and place tape 8" (20.5cm) to the left of the first piece of tape. Let the roll drop to the floor and smooth as in step 7. The 8" (20.5cm) between the pieces of tape will be your first tree!

9. Repeat the taping process for all the trees in your composition, varying the height and width. Taper the tips of smaller and shorter trees so they come to a point (A).

10. Fill a new roller tray with 1" (2.5cm) of white paint. Paint the corners and edges with white paint.

11. Load a small foam roller with paint and apply to interior portions of tree trunks using an up-and-down rolling motion. For wider trees use the width of the roller; for thinner trees turn your roller 90 degrees. Cover the paint tray with plastic wrap. Let the paint dry for at least 4 hours.

12. Remove the tape from the trunks, leaving the edges and baseboards masked: Pull the tape at a 90-degree angle, slowly and gently, in one long motion (B).

A TAPE STENCIL B TAPE STENCIL REMOVED

PAINT THE BRANCHES AND SKINNY TREES

13. Use a foam brush to paint branches. Larger trees will have thicker branches with more offshoots; smaller trees will have whisper-thin branches. Use the brush at different angles to make thicker and thinner lines (C).

14. When all branches are painted, have a seat on the floor. Good work!

15. To add a few small wispy trees, turn your brush to make a thin line that goes up from the baseboard about halfway up the wall. Move down a couple of feet and do one that goes one-quarter the way up the wall and another tall one, then a slightly shorter one then a really short one. Continue to vary line thickness by turning your brush.

PAINT THE LEAVES

16. Cut the oil board into 6" (15cm) squares.

17. Draw elliptical shapes in varying widths and lengths (or use leaf templates on page 162)— about 5 to 10 shapes should do it. Cut the shapes out to make leaf stencils.

C PAINTED
 BRANCHES

D PAINTED LEAVES

E PAINTED BARK

18. Open and thoroughly mix the bright yellow paint. Dip the tip of a stencil brush into paint and dab excess onto a palette.

19. Hold an oil board stencil on the wall and stipple leaves on branches with the stencil brush (D).

20. Move to another portion of the wall and stencil more leaves.

21. Repeat with all leaf stencils until you are satisfied with your forest. Let all the yellow paint dry at least 4 hours.

22. Gently peel off the painter's tape from the edges and baseboards.

23. Wash all brushes with warm soapy water and grab a tall cool drink. That was some fine painting there!

PAINT THE BARK TEXTURE
24. Pour 1 cup (.25l) of base coat paint into a plastic container. Add 1 spoonful of liquid black acrylic ink and mix thoroughly with a Popsicle stick. If a darker color is desired, add a spoonful of black at a time until the darker color is achieved.

25. Dip the tip of a stencil brush into the paint and brush light horizontal lines on the wider trees (E).

26. Paint knots by making nearly locking ellipses or ovals. It is good to see the brush strokes—they add texture.

27. Make small trees that begin at the baseboard with the dark paint. Give them delicate branches with your smallest stencil brush. Let dry for at least 4 hours.

TIPS
It's best to use synthetic brushes with water-based paint.

When choosing a room color, remember that colors appear much more intense than on the tiny color swatch. I usually choose a hue I like and go with one or two shades lighter on the swatch.

SUN PRINTING

Mysterious specimens glow on a metal shelf. Beakers full of colorful solutions bubble over flames. Cloaked in an embroidered lab coat and thick plastic glasses, I examine test tubes and scribble my conjectures on a black board. "Genius!" the Nobel Prize committee would exclaim when they honor my work to eradicate the common cold using tacos.

It turns out I am much better at drawing things than I am at remembering complex chemical equations, but the projects in this chapter give me an excuse to pretend. Cool science experiments meet photographic processes meet printmaking techniques. Lab coat is optional.

The printing methods we use in this chapter—cyanotype, screen printing, and solar-plate etching—require sunlight. We use images that function as a film positive, a light-sensitive material (cyanotype paper or fabric, StencilPro, or a solar plate), and a contact printer to make it all happen.

TOOLS AND MATERIALS

LIGHT-SENSITIVE MATERIALS

Cyanotype sensitizer: This solution comes as a mix. When applied to a surface, it light-sensitizes it to the sun. You can purchase kits that have instructions and the necessary chemicals in proportion and apply the sensitizer yourself with a brush or glass rod. Prepared emulsion can be stored in an amber glass bottle in a dark cool place for about six months. Getting an even coat of sensitizer can be challenging, and the kits make more solution than I need, so I prefer to leave the emulsion coating to the pros (listed in Resources, page 147) so I can focus on the fun stuff—printing!

Cyanotype paper: Because of its absorbent characteristics, watercolor paper is the best choice for cyanotypes. When you purchase paper that has already been coated with cyanotype sensitizer, you can bet the company that sold it to you did their homework and coated paper that would not chemically react with the sensitizer. When coating your own watercolor paper, you must use one that is pH neutral and additive free. I have used Arches® Aquarelle 140 lb (300gsm) hot press watercolor paper with good results. If after coating you notice the sensitizer looks more green than lemon yellow, there are impurities present in the sensitizer of the substrate.

Cyanotype fabric: Select a natural fabric with a fine weave, such as cotton or silk, and prewash and iron before coating it. Colored fabrics can also be used, but remember your color wheel and consider how the blue color of the finished cyanotype will affect the fabric color. If you are buying your fabric precoated, iron it (with dry iron set to the fabric type) on the wrong side before printing. Although the image is permanent, the fabric will need to be washed by hand with a nonphosphate soap detergent such as Woolite®. Dry cleaning and other soaps that contain bleach or soda will harm the print.

StencilPro™ film (photo-emulsion screen printing): StencilPro is a brand name for a film that has been coated with a photosensitive coating that, when exposed to sun and developed in water, hardens to form a stencil for screen printing. It can be purchased in single sheets or in a large roll and in two resolutions: regular and high, or "hi-res." The resolution refers to the number of threads per inch: The finer the weave, the finer the image quality will be. I advise using the regular weave for fabric and the hi-res for paper. Buy a few sheets. It is an easy process, but I recommend making some test prints first. The manufacturers of this product sell a product called PhotoEZ, which is identical in nature except that the film is green and the shelf life is about half as long.

Solar plate: Solar plates are sheets of steel coated with a photosensitive polymer. After exposure to sun and development in water, it turns into a relief plate. After printing, I usually take a rag soaked with a little mineral oil and apply a thin layer to protect the developed plate from moisture.

POSITIVES

Film positive: A film positive is an image created with black ink on a clear sheet of plastic. A film negative, used in most photographic processes, reverses the dark to light and the light to dark. With a film positive, we just keep the image as is. The cyanotype technique accepts images with tonality (a spectrum of black to gray), but StencilPro and solar-plate printing work best with a high-contrast image (just black lines

and shapes). There are several ways we'll make a film positive, and all methods will work with cyanotype, StencilPro, and solar-plate processes.

Digital film positive: If you are using an image you already have, like a template from this book, have your copy shop print the image on a laser transparency. You could also print an ink-jet transparency at home, but ink-jet transparencies don't usually provide a nice, dense black. Also, you are not going to have a home if you keep blowing money on all those pricey ink cartridges! Carefully examine the printed transparency by holding it up to the light. If you can see through the black inked areas, you will need to print out another and tape the two together. If there are just little spots that are allowing light through, you can fill them in with a black permanent marker.

Freehand film positive: Cut a roll of clear acetate into sheets or pick up transparency sheets at the copy shop. Draw or paint your design on the acetate with India ink and a brush or calligraphy pen. You could also lay your design under an acetate sheet and trace it. India ink is heavily pigmented so it won't let the light through; unlike watercolor ink, it contains shellac that allows it to stick to, and dry on, the acetate.

A heavily pigmented permanent marker will also work. Do not let oil from your hands get on the acetate—it will repel the water-based ink! If you need to clean the acetate, wipe it off with a cloth doused in little bit of rubbing alcohol. The India ink can be washed off with hot soapy water and the acetate reused if you are careful not to scratch the delicate surface.

OTHER STUDIO ESSENTIALS

Contact printer: A contact printer is used in most projects in this chapter to expose the light-sensitive material to the sun. It basically presses the film positive onto the light-sensitive material. Equal sizes of a ¼" (6mm) wood board and a ¼" (6mm) piece of glass make a good sandwich for the light sensitive material and film positive. See page 91 for instructions on how to make your own contact printer.

Wash basin: Many of the techniques in this chapter require development in water. Because the materials are light sensitive, it's best to keep your wash basin out of direct sunlight, which would further develop the material. A kitchen sink with plug and running faucet will do for small projects, but larger pieces will require development in the bathtub. Always use cool water. You will also need to rinse some materials in hydrogen peroxide.

The Sun's Muscles

The sun's strength differs according to time of day, season, geographical location, and weather. A cloudless summer afternoon with searing sunlight will require less exposure time than a winter sky where the sun chokes behind clouds. It is best to expose when the sun is high in the sky. The angle of a rising or setting sun will allow the light to sneak through the sides of the film positive, making muted shadows on the photosensitive materials. You can also make your own exposure unit at home with a fluorescent-light ballast. Exposure times for a home exposure unit will vary according to distance from the light and strength of the light emitted. I don't bother with all of that.

I take any chance I can to get out of the studio and work outside!

Darkroom: The light-sensitive materials we are using require strong light to expose, but unlike normal photographic materials that require a pitch-black room lit only with a red safelight, they can be worked in a dimly lit room. Think mood lighting. Fluorescent lights (and most other energy-saving bulbs) emit UV rays and need to be turned off. Candlelight would also add some extra light—and romance—without exposing the light-sensitive material.

"Light room": You don't need an actual room. You can expose your prints in any outdoor area that has direct sunlight. Just make sure the contact printer gets the strongest overhead sunlight possible. A picnic table is ideal, but I use the flat sidewalk in front of my walk-up apartment without trouble. After the set time for exposure, it is important to stop exposure (which prevents your print from receiving more light). Use a timer to keep track of how long your print has been exposed.

If I'm making a small print in a contact printer, I hold it to my chest, light sensitive-material facing in, run inside and immerse immediately in water. For a larger print I cover it with heavy-duty black trash bags and carry it inside.

Safety: I've used the nontoxic photosensitive materials featured in this chapter many times without gloves, goggles, or harm, but I might turn green tomorrow. Make sure you read the safety instructions that come with the photosensitive materials and take proper precautions. Chemicals and allergies are as divisive as disco and should be treated as such.

STRENGTH OF LIGHT SOURCES

WEAK/DIM · · · · · · · · · · · · · · · · · · · > STRONG/BRIGHT

CONTACT PRINTER

Contact printers press the film positive onto the light-sensitive material so the shadows that are created by the film positive are crisp. I had a frame shop cut a ½" (13mm) sheet of glass, which is very heavy; some people use a thin sheet of glass and clamps. Basically you can use any sheet of glass that is blemish free and larger than the light-sensitive material you are using. The base or board (I use plywood) is painted black to keep light from refracting on the back of the light-sensitive material that is placed on top of it. The size of your contact printer will depend on the size of the print you want to make, but this one should get you through most jobs.

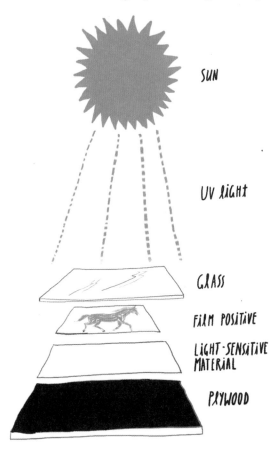

SUN

UV LIGHT

GLASS

FILM POSITIVE

LIGHT-SENSITIVE MATERIAL

PLYWOOD

MATERIALS
Paintbrush
Black acrylic paint
11" x 14" (28cm x 35.5cm) piece
 of ¼" (6mm) plywood
Light-sensitive material
 (cyanotype paper, StencilPro,
 or solar plate)
Film positive (artwork on
 clear acetate or laser copy
 transparency)
11" x 14" (28cm x 35.5cm) sheet
 of ¼" (6mm) thick glass

INSTRUCTIONS

1. Load the paintbrush with black paint and paint one side of the plywood. Set aside to dry.

2. Place the light-sensitive material faceup on the black wood panel.

3. Place the film positive on top of light-sensitive material.

4. Place the sheet of glass over the film positive.

5. Follow the project instructions!

TIPS

It is crucial that your glass and film positive are dust free on both sides. A can of pressurized air or an antistatic cloth will help.

Hardware stores and custom glass shops will have the thicker glass that works best here.

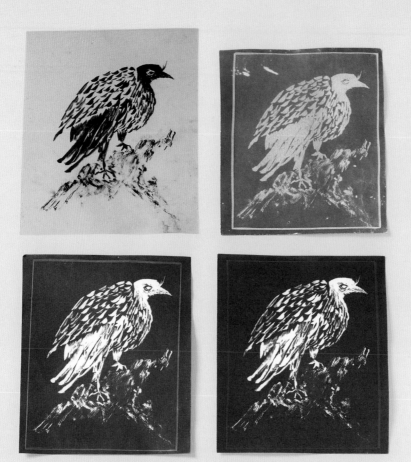

BASIC CYANOTYPE PRINT

This is the most adaptable and fun way to create a cyanotype. First we simply create a design with pen and ink and use that as the film positive to create as many cyanotypes as you wish. All source imagery will work—from designs with very simple, minimal detail to pieces with a fine line quality—so just go crazy. Because water-based ink can be opaque or semi-transparent depending on how thickly it is applied, we can take advantage of the tonality of the cyanotype medium.

MATERIALS

Template

8" x 11" (20.5cm x 28cm) sheet of
 clear acetate

Fine paintbrush

3 oz (85g) India ink

Water basin

8" x 11" (20.5cm x 28cm) sheet of
 cyanotype watercolor paper

Contact printer (page 91)

Timer

Hydrogen peroxide

Blotter paper

INSTRUCTIONS

PREPARE THE FILM POSITIVE

1. Print out the template on page 164, or make your own and place under the acetate sheet.

2. Trace the design on the acetate with a brush dipped in India ink and set aside to dry. This is your film positive.

EXPOSE IN SUN

3. Select a dry area outside that has direct sun exposure. A secure picnic table would be ideal. Inside, fill your water basin.

4. In a low-light area inside, place the cyanotype paper on the base of the contact printer, then place the film positive on top of the cyanotype paper. Place the glass over the film positive, making the contact between the glass and the substrate as tight as possible. While keeping the board level, carry everything out to the area of direct sunlight. Set the timer for 5 minutes.

5. Expose the print until the lemon yellow paper becomes a very dark blue. Exposure times will vary according to sun strength (latitude, season, time of day) and could be anywhere in the 5- to 25-minute range. Just watch the paper's color.

6. After exposure, bring everything back inside and remove the glass and film positive. Immediately place the cyanotype paper in the wash basin and turn on the water. Rock the basin back and forth to gently agitate the print. Agitate for 2–5 minutes or until the water in the wash basin runs clear.

7. Pour hydrogen peroxide over the print, return to the wash basin, and agitate for 30 seconds.

8. Remove the print and hang it to dry in a low-light area. When the paper is still a little damp, you can flatten the print by placing it in between two sheets of blotter paper (a thick and absorbent acid-free cotton paper), then weighing them under a large, heavy book.

TROUBLESHOOTING

If the print is too light, increase exposure time.

If the print is too dark, decrease exposure time.

If the print isn't as crisp as your film positive, the print moved while it was being exposed.

If the print doesn't have enough contrast, check your film to make sure the light source can't go through opaque black areas. If there are holes, cover them with black permanent marker or black India ink and try again.

If the print is yellow, the print was not agitated in water long enough. Return to wash basin and agitate for another minute.

Sunblock for Your Prints

To frame a print, purchase a frame that has UV-coated glass. Although a well-developed print is stable, the sun has the potential to fade nearly every photograph over time. If you are hanging prints directly on a wall, use a product like Krylon's Preserve It! that provides moisture resistance and UV protection.

PHOTOGRAM SEWING BOX

Photograms are prints made by placing objects, rather than a film positive, directly on the photosensitive material. My overstuffed sewing box was calling for an upgrade, so I picked up this cheap wood box at a craft store and spiffed it up with a little fine sandpaper. I dumped out the old box, searching for the most interesting shapes. I didn't want to use anything round because I knew it would roll around on the paper. Because we are using objects that have dimension, we don't need the whole contact printer. You just need a stiff dark board on which to place the cyanotype paper and the objects.

INSTRUCTIONS

1. Measure the size of the box lid. Subtract ½" (13mm) from both the length and width of the lid dimensions. In a dimly lit room, place the cyanotype paper on your cutting mat and cut it to the dimensions you have just calculated using a ruler and craft knife.

2. Place the trimmed cyanotype paper on the black board with the treated (yellow) side up.

3. Arrange the elements to be printed on the paper until you get the composition you want (A).

4. Carry the board with paper and objects outside. If the objects move during transport, quickly put them back into place—a few seconds won't hurt the result.

5. Expose the print until the greenish paper becomes a very dark blue (B). Exposure times will vary according to sun strength (latitude, season, time of day) and could be anywhere in the 5- to 25-minute range. Just watch the paper's color.

MATERIALS

Straight-edge ruler

Unfinished wood box with a lid smaller than 7¾" x 10¾" (19.5cm x 27.5cm)

8" x 10" (20.5cm x 25.5cm) sheet of cyanotype watercolor paper

Cutting mat

Craft knife

Black board from contact printer (page 91)

Assorted pieces from your sewing kit (scissors, buttons, bobbins, thread, etc.)

Wash basin

Hydrogen peroxide

Blotter paper

Mod Podge

2" (5cm) flat brush

Brayer

Rag and mineral oil (optional)

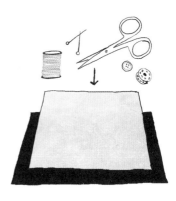

A

B

6. After exposure, bring everything back inside. Immediately place the cyanotype paper in the wash basin and turn on the water. Rock the basin back and forth to gently agitate the print. Agitate for 2–5 minutes or until the water in the wash basin runs clear.

7. Pour hydrogen peroxide over the print, return to the wash basin, and agitate for 30 seconds.

8. Remove the print and hang it to dry in a low-light area. When the paper is still a little damp, you can flatten the print by placing it in between two sheets of blotter paper, then weighing them under a large, heavy book.

9. Set to dry overnight. When the print is bone dry, turn it facedown on a piece of scrap paper. Paint a thin coat of Mod Podge to the back of print, and immediately apply a coat of Mod Podge to the box lid. Turn the print over and place it on box lid, sliding it into a position with equal ¼" (6mm) margins between the print and the box lid edge, measuring with a ruler if necessary. Roll a brayer over the print to get rid of air bubbles and bumps. Wipe visible Mod Podge off with a clean damp rag. Place a heavy book over the box and set aside to dry for at least 1 hour.

10. Apply a coat of Mod Podge over the print and lid. Let dry.

11. To seal the wood and bring out its grain, soak a rag with a little mineral oil and wipe the sides of the box with it, if desired.

Another Idea

Use other household objects to create a pencil box, a jewelry box, or a box of doilies (pictured at right).

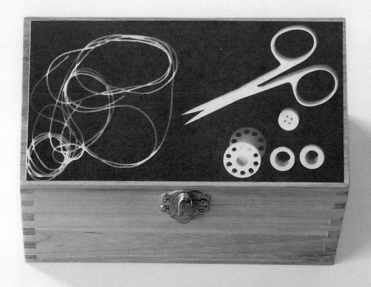

FREEHAND CORKBOARD

Chinese calligraphy comprises simple brushstrokes on a scroll of paper to create characters that reflect the energy and the individuality of the hand that painted it. I decided to translate this idea with my own handwriting, but I wanted to look at the text as a field created with rhythmic brushstrokes rather than individual words. I swapped out acetate for the paper and used English song lyrics, but kept the calligraphy brush and India ink.

INSTRUCTIONS

1. Unroll the acetate on a cutting mat and anchor it with heavy objects to keep it flat. Measure, mark, and cut one 32" (81.5cm) piece and one 50" (127cm) piece, marking the length with a permanent marker and cutting with a craft knife and ruler. Set the 50" (127cm) piece aside.

2. Secure the 32" (81.5cm) acetate to a flat work surface with 4" (10cm) pieces of drafting tape every few inches.

3. Dip the calligraphy brush into the ink. Holding the brush at a 90-degree angle, paint the text onto the acetate. (You may want to practice on a large sheet of scrap paper first.) Fill in the holes in letters like *a*, *e*, and *g*, as shown (A).

4. Leave to dry, taking care not to move the work surface. When there is no longer visibly wet ink on the acetate, move to next step. Drying time will vary by the amount of ink applied.

5. Cut a piece of fabric into two pieces: 36" x 54" (86cm x 137cm) and 26" x 36" (66cm x 86cm). In a low-light area, lay the fabric on the 20" x 30" (51cm x 76cm) board and let the extra fabric lay over the sides. Place the inked acetate on top of the fabric (B). Place rocks or pie weights on the dense black areas of the acetate to weight it to the board.

MATERIALS

25" × 12' (63.5cm × 366cm) acetate roll, .003" (.07mm) thick
Cutting mat
Straight-edge ruler
Permanent marker
Craft knife
Drafting tape
Bamboo calligraphy brush
3 oz (90ml) India ink
Scrap paper
Measuring tape
Scissors
3 yards (2.75m) of 36" (91cm) wide cotton cyanotype fabric, ironed flat with a hot, dry iron
2 pieces of ½" (13mm) fiberboard, 30" x 48" (76cm x 122cm) and 20" x 30" (51cm x 76cm)
River rocks or pie weights
Iron
Straight pins
Newsprint
Multipurpose adhesive such as 3M Super 77
Staple gun with ¼" (6mm) staples
2 friends
Level
Hammer and nails

A

B

C

6. Expose and develop as described on page 93. It is best to use your bathtub to rinse a print this size. Hang to dry.

7. When fabric print is just barely damp, lay it print side down on an ironing board and press on the wrong side with a dry iron on a cotton setting. This rids the fabric of wrinkles.

8. Lay the fabric print over the board again and situate it as you would like it to look on the wall. Use straight pins to secure the fabric to one of the ½" (13mm) sides of board. Trim a triangle of extra fabric away from each corner, leaving a 1" (2.5cm) gap between board edge and fabric. Go to a well-ventilated area and lay down some newsprint. Lay board faceup on newsprint.

9. Pull the fabric away from board along the edge opposite the pins, leaving the pinned edge in place. Apply an even coat of spray adhesive to the board and lay the fabric print back over board. Smooth out bumps with your hand to achieve a flat surface.

10. Lift the board so it is perpendicular to the work surface. With the print facing away from you, fold the excess fabric along the glued side over the edge of the board.

11. Staple the fabric 2" (5cm) from the edge with a staple gun. Place a staple every 5" (12.5cm) (**C**).

12. Remove the straight pins and turn the board 180 degrees. Repeat with the adhesive along the opposite side as in step 9.

13. Repeat this step for the other 2 sides, taking care to pull the clipped corners taut.

Print Workshop

14. Repeat steps 2–13 with the larger acetate and fiberboard.

15. Grab 2 pals and orient the boards on the wall. Use a level to check to make sure the boards are both straight. Mount them to the wall with nails in all 4 corners or more as needed, or hang using picture wire.

Other Ideas
Write your name!

Write out the names of herbs, veggies, fruits, or even a favorite recipe and hang the corkboard in your kitchen.

Put fabric-covered board behind your bed for a headboard.

Working with Boards

White face board is a type of fiberboard, sometimes called soundproofing board, available at most large hardware stores. The board I used for this and the dartboard project on page 139 is manufactured by Celotex. Sold in 4' x 8' (122cm x 244cm) sheets, I had it cut into a couple of pieces to save myself the trouble of cutting it; it also was much easier to fit the cut pieces in a cab. Homasote® is a brand name of fiberboard that could also be used, but it is much heavier.

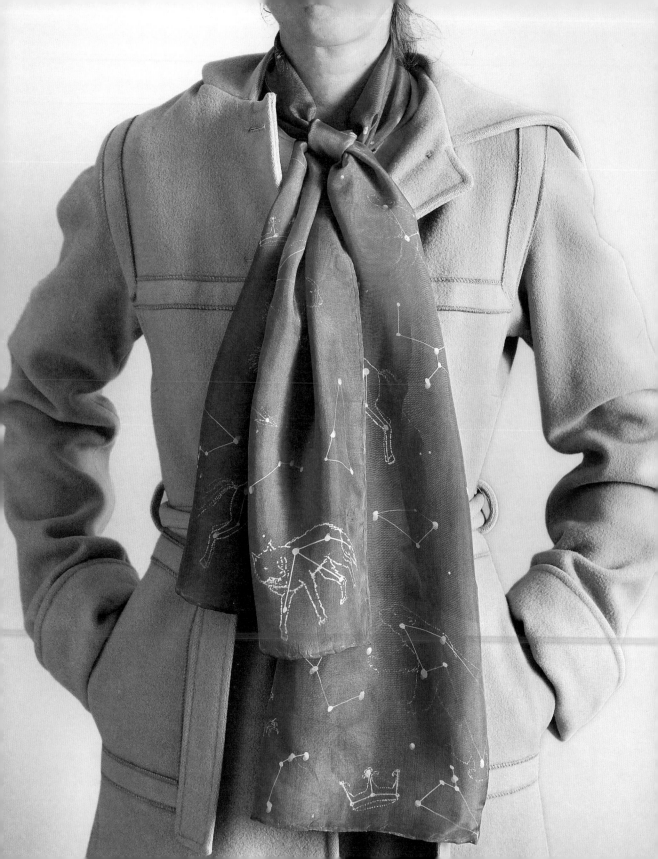

CONSTELLATION SCARF

Inspired by the rich Prussian blue of cyanotypes and old star atlases, I wanted to make a long scarf but didn't want to haul around a 5-foot (1.5m) contact printer to get it done. Like those illustrated in the star atlases I was checking out, I wanted beasts drawn with delicate curvy lines to contrast with straight lines and simple shapes that connect the constellation. I scanned my drawings and had them printed in several sizes on laser transparencies to create film positives. Without the heavy glass of a contact printer, I needed a way to weight the transparencies on the scarf. Straight pins and pearl-head straight pins were the solution, and from there form followed function. The pins kept the film positive flat on the fabric, and they also mimicked the starry night. After securing each little film positive with two or three pins, I filled in gaps with more straight pins to make a field of stars. I had the people at the hardware store cut my piece of foam (for the base) to size from 4' by 8' (1.2m by 2.5m) sheets, and I reserved the rest for other use. Don't forget to iron your scarf before printing by placing it facedown (shiny side down) and using a hot dry iron.

MATERIALS

36" x 72" (91cm x 183cm) dark solid-color fabric
64" x 24" x 1" (163cm x 61cm x 2.5cm) rigid insulation foam
100 straight pins
Template (page 165)
Three 8½" x 11" (21.5cm x 28cm) laser transparency sheets
Scissors
15" x 60" (38cm x 152.5cm) silk scarf with sensitizer (see Resources, page 147)
100 pearl-head straight pins
Wash basin
Iron

INSTRUCTIONS

1. Lay the dark fabric over the foam. Wrap excess fabric around the edge of the foam and secure with straight pins. This will be your contact printer board.

2. Print the template or your own artwork onto transparency sheets. Use scissors to cut individual constellations into rounded, smooth shapes.

3. In a dimly lit area, lay the scarf (shiny side facing up) over the fabric-covered foam board.

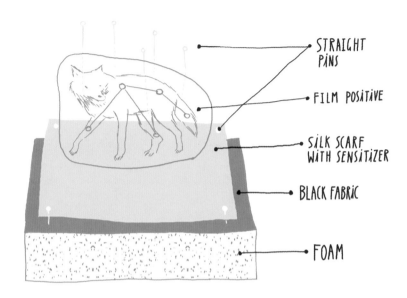

STRAIGHT PINS

FILM POSITIVE

SILK SCARF WITH SENSITIZER

BLACK FABRIC

FOAM

CROSS SECTION

4. Place the constellation film positives on the scarf and move them around until you have a composition you like.

5. Stick both pearl-head and straight pins into the black dots of the constellations and push them down until the heads are flush with the foam. Use 2 or 3 pins for each constellation.

6. When all constellations have been pinned to the foam, go back in and add more pins in areas without constellations to create single "stars."

7. Expose the scarf in the sun; exposure time will vary according to the strength of sunlight. Return the board to a dimly lit area. Remove the pins and develop the print according to instructions on page 93. Use a bathtub as your wash basin.

8. When the scarf is nearly dry, lay it facedown and iron on silk setting.

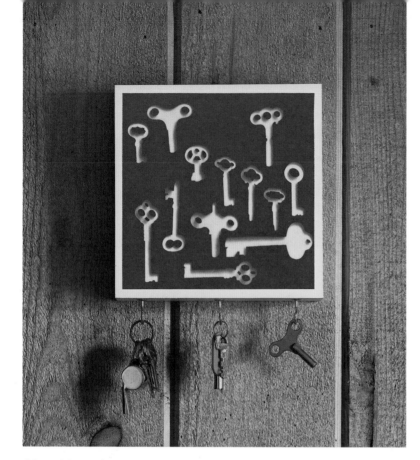

KEY HOLDER

This one goes out to my mother, sisters, old roommates, and groom, who all have valiantly fought by my side against the invisible forces that move my keys. Made exactly like the photogram sewing box (page 95) but applied to the face of a deep-cradled gesso board, sold under the brand name Gessobord™), this functional key holder might just end my lost-key battle for good. Might.

MATERIALS

Straight-edge ruler
Craft knife
8" x 11" (20.5cm x 28cm) sheet of cyanotype watercolor paper
Found keys
8" x 8" (20.5cm x 20.5cm) gesso board with 2" (5cm) cradle
Pencil
Drill and drill bits
Three 1½" (4cm) cup hooks (with shoulders)
Black board from contact printer (page 91)
Mod Podge
2" (5cm) flat brush

INSTRUCTIONS

1. Use a straight-edge ruler and craft knife to cut the cyanotype paper to a 7½" x 7½" (19cm x 19cm) square. Follow steps 2–11 of the Photogram Sewing Box technique (see page 95), using found keys for your composition and the gessoed board in place of the box lid.

2. Turn the gesso board so the bottom of the cradle is facing up. With a ruler and a pencil, draw a line 1" (2.5cm) from cradle edge. Mark lines at 1", 4", and 7" (2.5cm, 10cm, and 18cm) on the first line.

3. Load the drill with a bit slightly smaller in circumference than the hook's screw. Drill 3 holes ¼" (6mm) deep as marked. Screw a hook into each hole until the shoulder meets the gesso board cradle. The hook should face out.

CUP HOOK

4. Mount the board to the wall with a nail or screw. If you have thin walls, make sure to locate a beam.

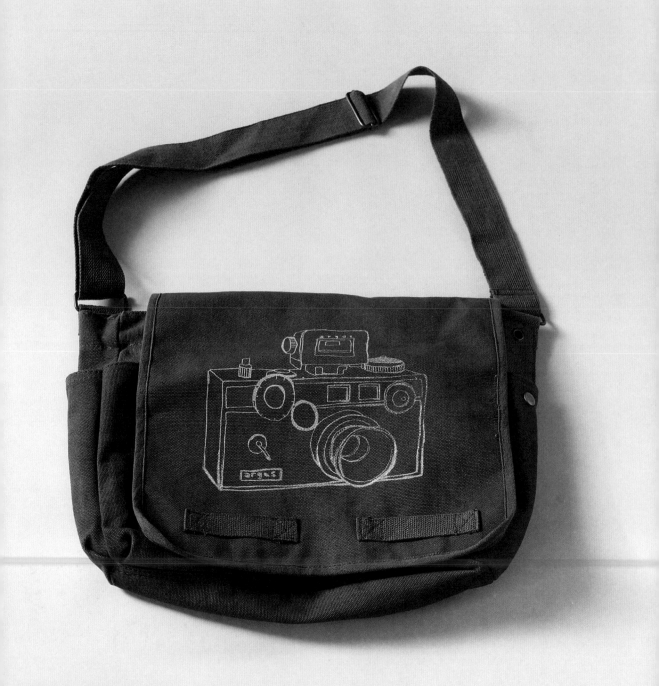

CAMERA MESSENGER BAG

Like any good nerd I collect things. Online auction sites have been fueling my addiction for collecting vintage cameras. Although I still like to put them to use, I also enjoy them for their forms. Today everything is designed to be sleek and tiny, but older cameras, with their intricate structures and turning knobs, have incredible personality. My friend and the photographer of this book, Doug, was marveling a recent score, an Argus C3. Turns out it was the first camera model he owned. I drew a portrait of the camera and and used a form of photographic screen printing to make a camera bag for him. You can create this with any tote bag or other natural fiber bag with at least one flat side. Remember to place heavy paper between layers if the bag's material is thin.

INSTRUCTIONS

1. Print the template or your own artwork onto laser transparency.

2. Peel the shiny protective backing from the StencilPro mesh sheet and place it on the board of the contact printer, shiny side facing up. Flip over the transparency so it is in reverse and place it over the mesh. Place the glass over the transparency (**A**).

3. Expose outside in direct sunlight for 45 to 60 seconds (**B**).

4. Move the contact printer to a dimly lit area, remove the mesh, place it in a basin of cool tap water, and soak for 10 minutes.

5. Scoop the plastic screen under the StencilPro sheet and gently rinse it with your sink sprayer or faucet. Examine the design carefully. If the lines of your design are not showing up, use a soft paintbrush to wipe away areas to be cleared.

MATERIALS

Template (page 166) or your own artwork
8½" x 11" (21.5cm x 28cm) laser transparency sheet
8½" x 11" (21.5cm x 28cm) StencilPro Standard sheet
Contact printer components (page 91)
Wash basin
Soft paintbrush
Paper towels
Messenger bag
Blue painter's tape
Scrap paper
Temporary spray adhesive, such as Sulky KK
8 oz (227g) fabric screen printing ink
Squeegee
Plastic needlepoint screen

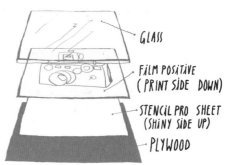

GLASS

FILM POSITIVE (PRINT SIDE DOWN)

STENCIL PRO SHEET (SHINY SIDE UP)

PLYWOOD

A

EXPOSED STENCIL PRO SHEET

B

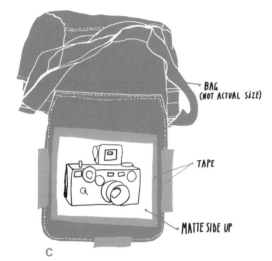

BAG (NOT ACTUAL SIZE)

TAPE

MATTE SIDE UP

C

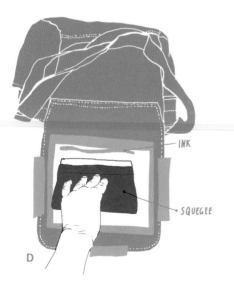

INK

SQUEEGEE

D

6. Lay the mesh, shiny side down, on a paper towel and carefully blot off excess moisture. Place the mesh on a dry paper towel and return to the sun for another 10–12 minutes.

7. Open the messenger bag and lay the front flap on a work surface with right side up. Secure the 3 available edges of the flap with long strips of painter's tape.

8. Turn the stencil over onto a piece of scrap paper and apply a light coat of spray adhesive. Be careful not to spray too much—it can clog the mesh! Turn the stencil over and adhere it in position to the messenger bag flap.

9. Use strips of painter's tape to secure the exterior edges of the stencil (C).

10. Drizzle 4 spoonfuls of screen printing ink on the short side of the stencil not far from the design. Holding the squeegee at a 45-degree angle, dab it along the ink line so the entire edge of the squeegee has ink on it, and then pull the squeegee across the surface of the stencil sheet (D).

11. Gently pull one corner of the print up slowly to make sure the ink has gone through. If the ink application is too light, lay the corner back down, add more ink, and go over the stencil with the squeegee again (E).

12. Remove the stencil and the bag and wash the stencil immediately with warm water, being careful not to touch the shiny side of the stencil.

13. Let the print dry, then heat-set it according to ink manufacturer's instructions.

TROUBLESHOOTING

If the design is on the screen but not washing out, either the exposure was too long or the negative is not dark enough.

If the design is not appearing on the screen, there was not enough exposure.

If the design is on the screen but it is fuzzy, make sure the negative has proper contact with the screen during exposure. Check the design—it may be too detailed and you'll need to switch to higher mesh count.

If the ink is bleeding through the sides of the design, the stencil has moved during printing. Use more adhesive spray.

If the ink not going through, use more pressure when applying the ink or thin the ink with a small amount of water.

Mesh Counts

Mesh count refers to the number of threads per square inch. The higher the mesh count, the more detail you can get, but less ink will pass through. Canvas fabric is very thirsty and textured, so you want to go with a lower mesh count so a lot of ink can be transferred. Paper is not as absorbent or textured, so we can use a higher mesh count to get a crisper and more detailed image on the substrate. Stencil-Pro comes in two mesh counts: Standard 110 mesh count and High Resolution (HiRes) 200 mesh count. If you already have made a contact printer, just buy the plastic needle-point screen from the craft store and the squeegee. If you don't have the contact printer, spring for the StencilPro beginner's kit.

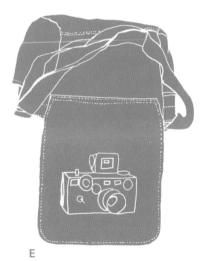

E

PARTY

EMILY'S DAY
.
SEVEN O'CLOCK
>>> > > > > > > >
TWO FOUR SIX OAK ST.
<<< << < < < < <
PLEASE BRING ONE DISH!
.

PARTY

EMILY'S DAY
.
SEVEN O'CLOCK
>>> > > > > > > >
TWO FOUR SIX OAK ST.
<<< << < < < < <
PLEASE BRING ONE DISH!
.

PARTY

EMILY'S DAY
.
SEVEN O'CLOCK
>>> > > > > > > >
TWO FOUR SIX OAK ST.
<<< << < < < <
PLEASE BRING ONE DISH!

PARTY

EMILY'S DAY
.
SEVEN O'CLOCK
>>> > > > > > >
TWO FOUR SIX OAK ST.
<<< < < < < < <
PLEASE BRING ONE DISH!
. . . .

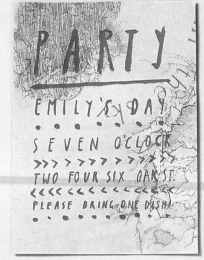

PARTY

EMILY'S DAY
.
SEVEN O'CLOCK
>>> > > > > >
TWO FOUR SIX OAK ST.
<<< < < < < < <
PLEASE BRING ONE DISH!

PARTY

EMILY'S DAY
.
SEVEN O'CLOCK
>>> > > > >>>>
TWO FOUR SIX OAK ST.
<<< < < < < <
PLEASE BRING ONE DISH!
.

PARTY TIME WITH STENCIL PRO

Here at Yellow Owl Workshop we make tons of event invitations, and one way we keep things fresh (and Mother Earth-lovin') is by using found paper. Leaves torn from old books. Found postcards and maps. Pages from the scrap bin. Nothing is safe from ink in this studio. We just cut everything to the same size and get to printing. StencilPro is great for making an edition of prints quickly, and in this method we print on a transparency to register our prints so they print in the same place each time. After you learn this technique, you'll be having parties just to print the invitations!

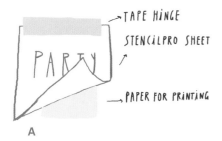

TAPE HINGE
STENCILPRO SHEET
PAPER FOR PRINTING

A

MATERIALS

Two 8½" x 11" (21.5cm x 28cm) laser transparency sheets
8½" x 11" (21.5cm x 28cm) StencilPro HiRes sheet
Contact printer (page 91)
Wash basin
Plastic needlepoint screen
Soft paintbrush
Paper towels
Scrap paper
Blue painter's tape
Popsicle stick
8 oz (227g) fabric screen printing ink
Squeegee
8½" x 11" (21.5cm x 28cm) pieces of found paper
Pencil

INSTRUCTIONS

1. Follow steps 1–6 of the Camera Messenger Bag project (page 107) to expose and develop the StencilPro HiRes sheet.

2. Lay scrap paper on the work surface and secure each corner with painter's tape.

3. Lay a blank transparency sheet over scrap paper and secure to the work surface with an 8" (20.5cm) strip of tape along the left side.

4. Lay the StencilPro sheet, shiny side down, on top of the blank transparency sheet and secure the top edge to the work surface with an 8" (20.5cm) strip of tape **(A)**.

5. Using the Popsicle stick, spread 2 tablespoons (30ml) of ink below the tape line.

6. Hold the squeegee and pull in one motion over film **(B)**.

7. Lift the StencilPro sheet and align the found paper under the transparency sheet. Remove transparency sheet and outline found paper with a pencil.

8. Lay StencilPro film down again and print. Remove the printed found paper to dry.

9. Place a new piece of found paper in the outline and continue printing, replenishing ink as necessary.

10. After printing, remove the stencil and wash it immediately with warm water, being careful not to touch the shiny side of the stencil.

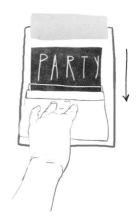

B

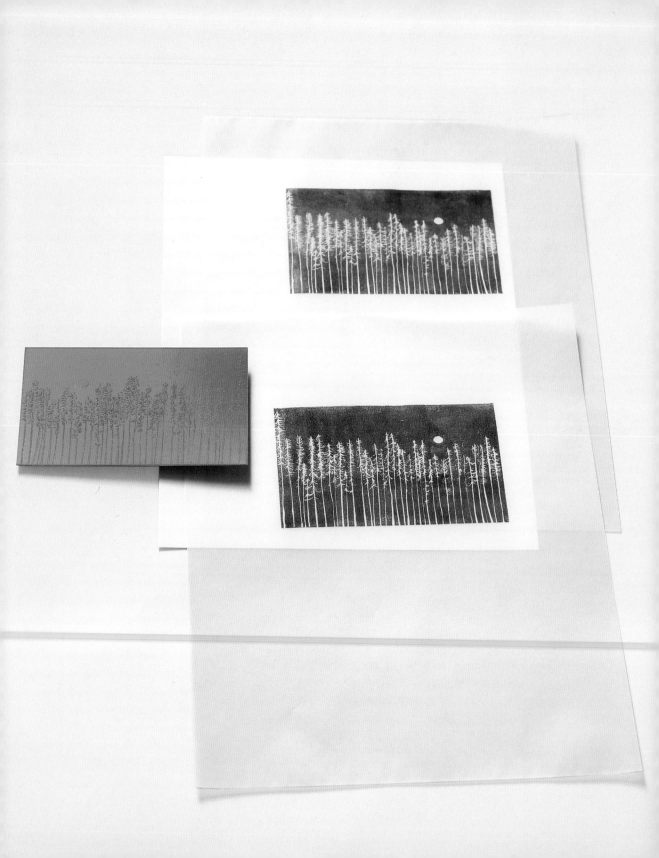

MOON + TREES SOLAR-PLATE PRINT

I guess you could call this the cheater's way of relief printing. It's also called photo-etching, photogravure, or solar-plate etching. Basically, you use a bone folder for printing rather than a barren because you need to use more pressure to get a crisp print. I use vellum because it is slightly translucent so it is easy to see where you need to burnish more. And it is very strong so it can take the direct pressure from the burnishing bone folder.

INSTRUCTIONS

1. Carefully read the solar-plate manufacturer's instructions for exposure times. Print out the template or your own artwork onto the laser transparency sheet. Trim the sheet to the size of solar plate, 5" x 7" (12.5cm x 18cm).

2. In a dimly lit room, remove the protective sheet from the solar plate and place the plate orange side up on the contact printer. Turn the transparency over so it is facedown—the design will appear in reverse. Place the sheet of glass over the transparency and set it under direct sunlight.

3. Expose for 1–5 minutes; 1½ minutes usually works on a sunny day. Promptly return to a dimly lit room. Extract the solar plate from the contact printer and submerge it in a wash basin filled with cool water for about 5 minutes. Holding the plate gently from the back, dip the brush in water and brush the design. The areas that were black in your design will wash away. The face of the solar plate is still very fragile, so be gentle! Blot the surface with newsprint to absorb pooling water.

4. Take the solar plate into the sun for hardening, about 15–30 minutes.

MATERIALS

5" x 7" (12.5cm x 18cm) solar plate template (page 167)
8½" x 11" (21.5cm x 28cm) laser transparency sheet
Scissors
Contact printer (page 91)
Wash basin
Soft paintbrush or mushroom brush
Clean newsprint
2½ oz (70g) liquid block printing ink
Paint palette
4" (10cm) brayer
8" x 10" (20.5cm x 25.5cm) sheets of scrap paper
8½" x 11" (21.5cm x 28cm) sheet of hosho paper
Wax paper
Bone folder
Paper towels

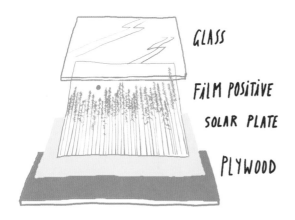

GLASS

FILM POSITIVE

SOLAR PLATE

PLYWOOD

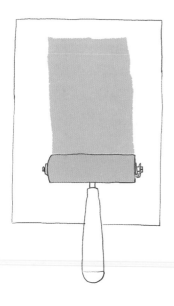

5. Add a nickel-sized amount of ink to the palette. Roll the brayer through the ink to coat it with an even layer.

6. Place the solar plate on a piece of scrap paper and roll the brayer across the plate's surface. Pick up the piece of paper and the solar plate and slide the inked plate to a clean sheet of scrap paper, ink side up. Lay a piece of hosho paper on top of plate, then lay a sheet of wax paper over the hosho.

7. Burnish with a bone folder. As you burnish you will be able to tell where the ink has transferred through the semitransparent paper. Hang the print to dry.

8. Rinse the solar plate off in cool soapy water and blot with paper towel. When dry, store the plate for future use in the black plastic sleeve it came in; if you leave it out in direct sun it will become brittle.

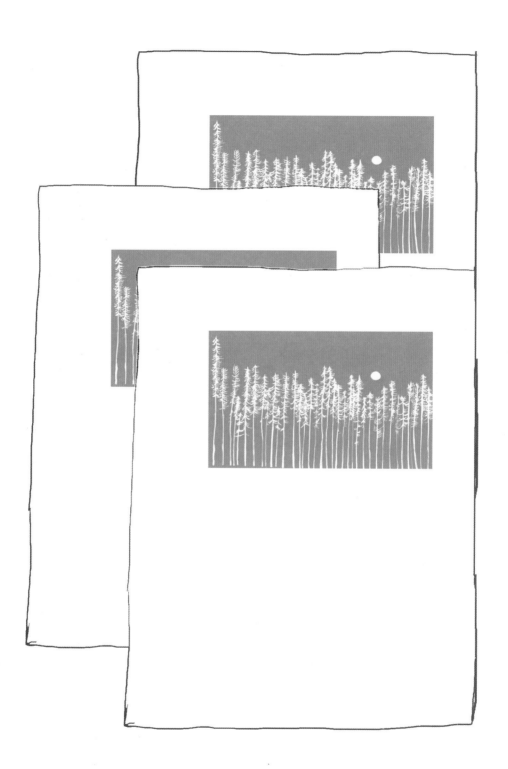

IMAGE TRANSFER PRINTING

Technology gets a bad rap for being cold and removed, but you can use it to make personal handcrafted work! There was a time when buying paint in premixed tubes was radical, and we all know what the art-supply store looks like now.

Once you ditch the skepticism and get a handle on the techniques, you'll see that image transfer is a wide-open field, full of possibility. You will find it infinitely more useful than you thought. In this chapter, we'll do some digital printing the way it was meant to be done, but we'll also use machine-made prints as a springboard for our own homemade editions.

Since most of the projects in this chapter begin with a print from an ink-jet printer, a laser printer, or an offset printer, it's good to know a little bit about how these devices work before you get started. Each creates images with a different type of ink, and you really have to make sure you use the correct printing process for each image transfer. I try to explain the basics on page 119, and each project will tell you what kind of printer you should use. Don't worry if you don't have an industrial laser printer or photocopier at home—the local copy shop is always more than happy to let you use theirs, and it's usually cheaper than you'd think.

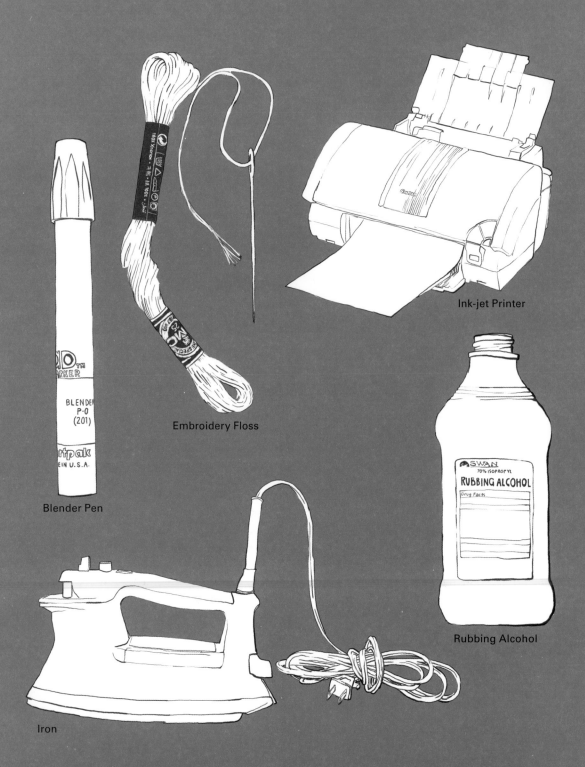

Blender Pen

Embroidery Floss

Ink-jet Printer

Rubbing Alcohol

Iron

TOOLS AND MATERIALS

TRANSFER PAPERS

Transfer paper: Transfer paper is essentially a piece of paper coated on one side with pigment. The pigmented side typically lays facedown on another piece of paper and the transfer happens whenever it is marked with a hard object. The pressure applied by the object—usually a writing utensil—is what transfers the image, not the ink. Carbon paper is probably the most common example, and anybody who has received a check at a diner has seen this technique. While the people who serve me amazing pie may not appreciate it, I love transfer paper because you can get a wide range of tonality (think gray scale from white to gray to black)! You can find it at office supply stores, and the manufacturer Saral even makes a line of colorful transfer papers that work on many surfaces.

DIY Transfer Paper

To make your own transfer paper, just rub pencil lead, oil pastel, or chalk pastel on a piece of paper and turn it over. Then mark the top side with a pen, and your transfer will be in whatever color you have chosen!

Water-slide decals: There are commercially available lines of water-slide decal paper on the market, but I am not a fan. The plastic sheets melt in laser printers and the ink-jet version requires several coats of sealing before it is ready to go. And why look elsewhere when the items in your home work just as well? To make your own, adhere a photocopy to clear packing tape or clear contact paper and then submerge it in water and rub. After a couple minutes, only the ink from the photo or laser copy remains on the tape. Note: You cannot use an ink-jet print for this!

Iron-on transfer paper: This type of paper is great for getting a photographic image onto fabric, and you get photographic quality too! Iron-on transfer sheets for light fabric have a clear backing so the image appears to float on the fabric. Iron-on transfer sheets for darker fabrics have a white backing sheet so the image will show up. Buy Avery® T-shirt transfers! The product is consistent and holds bright colors. I tried three other brands and the results were miserable: The decal was shiny and looked cheap against the fabric, or worse, it took forever to iron on or never ironed on. Even if you buy the best brands, iron-on transfers are not meant for everyday wear. They will eventually fade or wash off. If you are considering multiple prints or projects that will require frequent washing, consider using a place like Spoonflower (www.spoonflower.com) to digitally print directly on your fabric instead. These digital processes are becoming more accessible and affordable by the day.

PRINTERS

Ink-jet printers: These guys are the most common home printers. They spray tiny drops of a water-based solution of dye or pigment to create the image. The printers, priced according to how many tiny drops per inch they can spray, are cheap—but the ink cartridges aren't. Pigment-based inks provide brighter images with more archival quality than the dye-based inks. Giclee is pretty much a higher-quality version from a professional shop (or a wealthy individual) that is often used to copy fine art materials. No matter what kind of ink-jet you use, the ink is water-based, so the prints are not waterproof and must be sealed with a spray sealer or Mod Podge.

Laser printers and photocopiers: These printers use toner made of pigment and plastic. Static electricity pulls the toner to the page and heat then melts the toner onto the paper.

Offset printers: Offsets use a plate coated with oil-based ink to transfer an image onto a blanket and then onto a substrate (usually paper). This is the type of printing is economoical for large quantities—magazines, glossy grocery circulars, and newspapers—because the majority of the cost is for the plate setup.

OTHER MATERIALS

Solvent: I prefer Chartpak® AD™ Marker blender pen. In the days of yore most art markers were made with a chemical solvent called xylene, but as far as I know this is the only company still making them. The blender pen is normally used to blend the colors of several markers, but we're going to use its clear solvent properties to transfer images. This is the method to use for a crisp photographic image. Solvent transfer is great to transfer any photocopied image (other than ink-jet) onto porous surfaces like paper, fabric, or wood—but the smoother the surface, the clearer your image will be.

Clear packing tape: We use this to make our own water-slide decal paper. Packing tape is sold according to thickness, and the thinner the better, since you want the decal edges to disappear. Typically you want to buy the 1.7mm tape, not the 3mm heavy-duty version.

Iron: Iron-on decals require one of these. Turn it to the cotton setting and dump all the water out—you do not want any steam messing up the transfer!

Embroidery floss: Embroidery floss is basically several stands of thread twisted together to make a thicker string. These threads can be pulled apart to make thinner strings or wound together to make an even larger string. You really need to cut this stuff with the sharpest scissors you have; dull scissors will make a dull cut, and it is a pain to thread a needle with ratty ends.

ON-THE-GO JOURNAL

I spend a lot of time in my studio. A lot. And anytime I escape, if even it's just to the coffee shop, I carry around a sketchbook to record things that catch my interest. In this project, I use the Chartpak AD Marker blender pen because it's great for transferring color and fine details onto fabric, wood, and paper. Since the image will transfer backwards, if it has any text just reverse the image first on your computer by scanning it and flipping using photo management software.

MATERIALS

Photocopy or laser print of image to be transferred

Chartpak AD Marker blender pen

Paper

Bone folder or back of metal spoon

INSTRUCTIONS

1. Saturate the paper area you want to transfer with the blender pen.

2. Place the photocopy facedown on the paper.

3. Saturate the back of the photocopy with blender pen.

4. Burnish with bone folder.

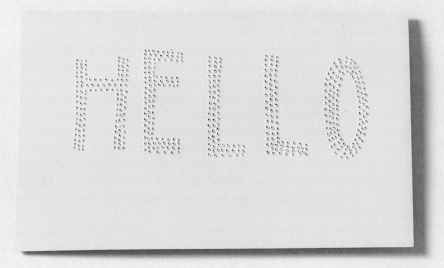

PiN-PRiCK STATiONERY

This is a fast and simple way to make some stationery with a cool relief texture— even five minutes before you have to go to a party. And the best part is you have everything you need already. This is a form of debossing and die cutting; embossing (pressing in) and debossing (pressing out) are the two forms of blind, or "without ink," printing. Die-cutting makes a hole the same size as the die. A hole punch makes a die cut because it cuts the same size shape out every time.

INSTRUCTIONS

1. Hold the template or artwork copy up to a sunlit window and trace with pencil.

2. Place the unfolded card facedown on cardboard (**A**) and place the template, pencil side up, on the card.

3. Holding the pushpin with your thumb and pointer finger, press it through the lines in the template (**B**).

4. Repeat until you have traced the template with pinholes.

TIP
If you find your template or card is moving around, secure it to the cardboard with drafting tape.

MATERIALS
Photocopy of template (page 163) or your own artwork
Pencil
Blank stationery cards and envelopes
Cardboard
Pushpin

Other Ideas
Wrap the finished paper around a votive candle.

Purchase thin sheets of aluminum from a hardware store and use a hammer and nails to create the design. You can scratch a template out with the head of a nail.

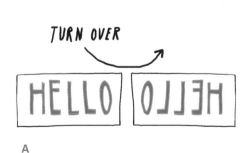

A

B

HEY MOM,
WE ARE IN D.C. STOMPING ON

THE OLD GROUNDS JUST YEAH

MARY BETH SCHMIDT
'1 FOLSOM ST
SAS CITY, MO
9 1 1 3

GREETiNGS FROM HEAVEN

It was a sad day when Polaroid stopped making instant film. Polaroid lovers rushed to their computers to sweep up all available film, especially the coveted 690 film used for Polaroid transfer. Absence makes the heart grow fonder, and it does have a way of whitewashing the truth. Truth is, as cool as Polaroid transfer was, it was kind of a pain. You needed the film—which was about a buck a picture and not easy to find—as well as a 35mm slide negative and a day lab or land camera (which had been out of production for years). I discovered a much easier and more versatile way to make transfers with Sheer Heaven™ paper. Unlike water-slide decal paper, which basically leaves a film covered with ink on the page, the alcohol suspends the ink from the Sheer Heaven and allows it to soak into the paper—just like our beloved Polaroid transfer! I recommend doing a few test transfers with scraps of paper and a cutout sheet of Sheer Heaven till you get the hang of it. Even if the whole image doesn't transfer, you can still enjoy the effect.

INSTRUCTIONS

1. Rinse out the spray bottle thoroughly and fill with rubbing alcohol.

2. Scan in your vintage postcard and open the file in a photo-editing program.

3. Enlarge the postcard to the desired size and enhance the color saturation.

4. Type or draw your text in and remember to add names, date, and location in reverse image! Set printer to a fine-quality photograph setting.

MATERIALS

Clean plastic spray bottle with fine mist spray nozzle

70% isopropyl rubbing alcohol

Computer with scanner, ink-jet printer, and photo-editing program

Vintage postcard

Five 8½" x 11" (21.5cm x 28cm) sheets of Sheer Heaven ink-jet transfer paper

Scissors or craft knife

Scrap paper

Bone folder (optional)

20 pieces of 3½" x 5¼" (9cm x 13.5cm) watercolor paper with deckled edge

ORIGINAL

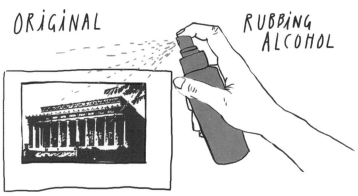

RUBBING ALCOHOL

SHEER HEAVEN SHEET

A

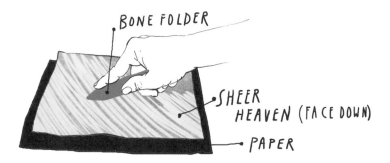

BONE FOLDER

SHEER HEAVEN (FACE DOWN)

PAPER

B

PRINT!

5. Format the file so you can print 4 images on each 8½" x 11" (21.5cm x 28cm) page and make 5 ink-jet prints. (Note: Sheer Heaven has one smooth side and one side with a velvety texture. Print on textured side.)

6. Print and cut the sheets, leaving a ½" (13mm) margin around each print.

7. Arrange your work space into 2 areas—a wet area with a piece of scrap of paper and a dry area on a clean work surface.

8. Lay a transfer print faceup on scrap paper in the wet area and lightly spray with an even coat of rubbing alcohol **(A)**.

9. Working quickly, turn the print over onto watercolor paper in the dry area and burnish with a bone folder or your fingernail **(B)**. Peel back a corner of the transfer sheet to make sure the image is transferring.

10. Pick up one corner of the transfer sheet and slowly peel it away from the watercolor paper.

11. Add a stamp and stick it in the mail.

TROUBLESHOOTING

If the image doesn't transfer, spray with heavier coat of alcohol and repeat.

If the Sheer Heaven isn't pulling away from paper or is peeling the top layer of paper, work more quickly and repeat with less spray.

Other Ideas

Sheer Heaven art paper and the same technique can also be used to transfer images to fabric. This would be great for a decorative pillow or other cloth piece that is not to be washed. Use this technique to transfer images into a scrapbook or photo album.

TIPS

The smallest size allowed for a postcard in the United States is 3½" x 5¼" (9cm x 13.5cm).

Postage for a postcard is usually 40 percent less than for first class mail.

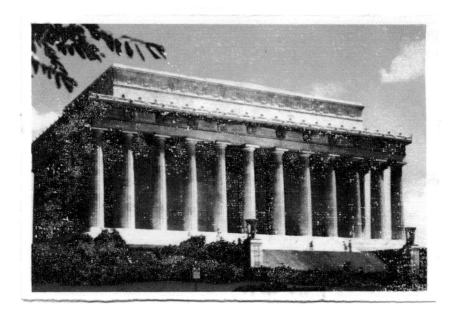

TRANSFER-PAPER MOBILE

Transfer paper is infinitely useful for creating patterns or templates. In this project, inspired by the mobiles of Alexander Calder, I use carbon paper and the chipboard from the back of a pad of legal paper to create a kinetic sculpture, which changes composition as it rotates gently in the wind.

MATERIALS

Template (page 168)
Two 8" x 10" (20.5cm x 25.5cm) sheets of chipboard (or single-ply mat board)
Carbon paper
Craft knife
14-gauge nail
Hammer
3 tubes of 2oz liquid acrylic paint: 1 black, 1 yellow, and 1 red
1" (2.5cm) foam paintbrush
Wire cutters
60" (152.5cm) 16-gauge galvanized wire (note: Wire is measured by diameter; the smaller the number, the fatter the wire)
Needle-nose pliers
Fishing line

INSTRUCTIONS

1. Trace outlines and wire holes from the template onto chipboard with carbon paper and cut the shapes out with a craft knife.

2. Place the nail on a wire hole outline and use the hammer to create a hole. Repeat for all mobile pieces.

3. Paint shapes A, B, C, and D black on both sides. Paint shape E yellow on both sides. Paint shape F red. Set aside to dry.

4. Use wire cutters to cut five 12" (30.5cm) lengths of wire. Make U-shaped loops at both ends of each wire with pliers. You now have wires I, II, III, IV, and V.

5. With wires I, II, III, and IV, make an O loop 4" (10cm) from one end. With wire V make an O loop in the middle of the piece (6" [15cm] from the end).

6. Tie fishing line to the O loop on wire I and suspend it from the ceiling. Hook shape A through the U loop on the long end of wire I.

7. Hook the O loop of wire II through the other U loop on wire I. Hook shape B through the U loop on the long end of wire II.

8. Repeat with the remaining shapes and wires, using wire V for both shapes E and F.

9. Close the U loops with pliers and adjust any kinks in the wire with your hands.

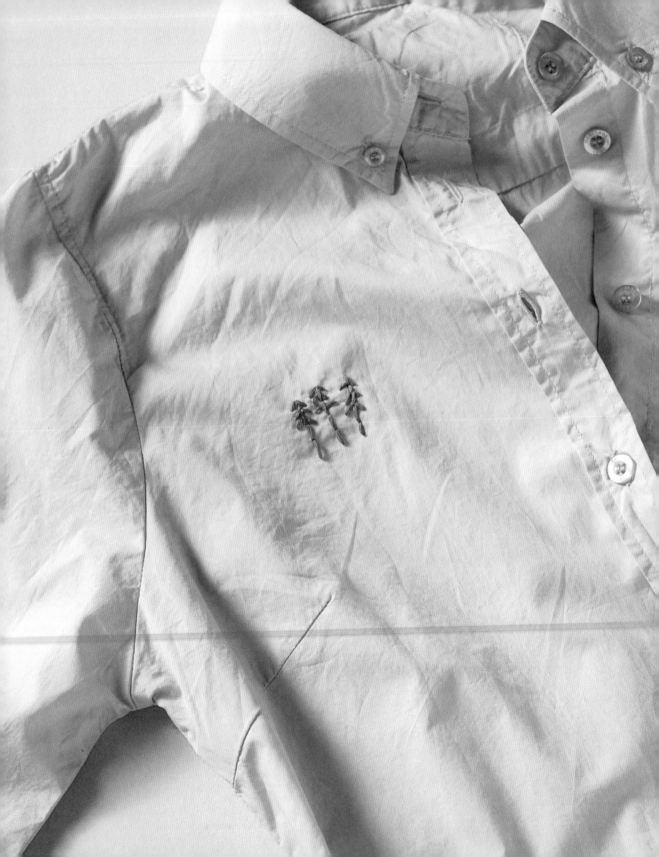

PERSONAL POLO SHIRT

MATERIALS

5" (12.5cm) square of paper

1 used dryer sheet

5" (12.5cm) square of carbon
 paper

Ballpoint pen

Shirt or sweater, washed
 and pressed

Drafting tape

5" (12.5cm) embroidery hoop

1 skein embroidery floss

Embroidery needle

Scissors

Tweezers (optional)

Besides watching that scene in *Pretty Woman* where Julia Roberts attends a polo match donning a giant hat, I have no associations with the sport. And I certainly don't feel like paying to advertise for the company that brands their preppie gear with a tiny polo player. I want my own logo; a little emblem that makes my threads more personal. In this project you create your design on a sheet that attaches to your fabric, and you sew through both layers to transfer the pattern. Once you remove the dryer sheet, the design remains on the fabric. I am not a needlecraft pro and didn't want to spring for the expensive stabilizer sheets, so I used a dryer sheet.

Embroidery is just like drawing with thread, and, like a drawing, it can be as simple or as detailed as you want. Because you make the lines out of stitches, a curved line is more challenging than a straight line. The world is full of complicated embroidery patterns that you can track down online, but I kept it simple because it is not only easier but more unexpected. You might what to try out a few designs on some scrap fabric before you move to an expensive garment.

INSTRUCTIONS

1. Create a template by drawing your design on paper. Place the dryer sheet on a flat work surface. Place carbon paper over dryer sheet, shiny side down **(A)**. Place the drawing over the carbon paper and trace image with ballpoint pen onto the dryer sheet. With one hand holding the paper down, curl back the carbon paper to make sure image has transferred onto the dryer sheet.

2. Lay the garment on a flat work surface. Place the dryer sheet pattern on the area you want to embroider and secure it with 1" (2.5cm) pieces of tape on all four sides.

What Is a Back Stitch?

This simple stitch creates the look of one continuous line and is worked from right to left with a circular motion. Push the needle through at the rightmost edge of the line and bring it back up one stitch length ahead on the left.

BACK STITCH

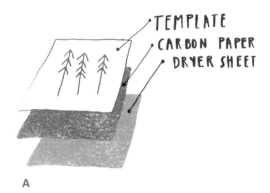

TEMPLATE
CARBON PAPER
DRYER SHEET

A

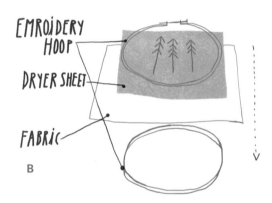

EMROIDERY HOOP

DRYER SHEET

FABRIC

B

C

3. Place the smaller embroidery hoop inside the garment, under the pattern. Place the larger hoop on top and press it down onto the small hoop. Pull the fabric so it is taut in the hoop and turn the metal screw on the outside hoop until the fabric is wedged tightly in the hoop **(B)**. Make sure that only the fabric you want to embroider (usually the front of the garment) is in the hoop **(C)**. If both sides of the garment are in the hoop you will be sewing your garment together. Fool me once!

4. Thread 18" (45.5cm) of embroidery floss though the needle and tie a knot at one end. Put your nondominant hand inside the garment and hold the hoop. With your dominant hand, push the needle through one line of your design, from back to front, and pull gently through both layers.

5. Push the needle back through fabric a short distance along the line of the pattern. To form a back stitch, bring the needle from front to back at the halfway point of the stitch just made. Continue to make simple stitches by going into the fabric two steps forward, and coming out one step back until the design is completed.

6. Continue backstitching until your design has been completed. Weave the tail of thread back through design and cut off any excess.

7. Trim the dryer sheet closer to the design and use tweezers or a pin to remove any residual pieces of the dryer sheet. If any remain, they will come out in the wash.

WATER-SLIDE DECAL JARS

Each November, some pals come over to brine green olives fresh from the farmers' market. Really, throwing olives in a jar full of vinegar and lemons is an excuse to hang out—just like the Super Bowl, minus the sports or sweat. At the close of the event we are rewarded with luminous green jars, and like any good trophy, these giant jars of olives need an inscription. The first year I used water-slide decal paper, but I had to seal the paper several times with clear aerosol spray. I wanted something more immediate and better suited for making a series of labels. The next year I made my own, and I have to say that this process definitely wins! If you want to make a label larger than the width of the packing tape, just use clear contact paper.

Kindly mail me a jar of whatever you have made. Chances are I am hungry!

MATERIALS

Template (page 169) or your own labels
Clear packing tape
Bone folder (optional)
Bowl of lukewarm water
Clean glass jars
Cloth and 70% isopropyl rubbing alcohol (optional)
Clean rag
Mod Podge Gloss
1" (2.5cm) flat brush

INSTRUCTIONS

1. Print your labels—in color or black-and-white—on a laser printer or just photocopy the template. Do not use inkjet print.

2. Cut a piece of tape and lay it over the printed design paper. Burnish with bone folder or fingernail.

3. Cut the paper along the tape's edges and submerge the tape in the bowl of water for 5 minutes.

4. Remove the tape from the water bath and turn it paper side up. With your finger, gently rub away the paper so that only the ink remains on the tape. If you are making a long strip, start at the top and roll the paper down and off the strip of tape.

5. Cut the tape transfer into the label size you want and adhere to the outside of a jar (I recommend spending an extra minute and cleaning your jar first with a cloth soaked in rubbing alcohol). Beginning at the center, smooth the label out with your finger to remove any air bubbles.

6. With the rag, wipe away any excess water and paint an even layer of Mod Podge over the label and its edges. The gloss medium will disappear when it is dry, so no worries.

TROUBLESHOOTING

If the paper isn't rubbing off easily, try soaking it longer.

If the inked portions of the image rub off, repeat the process with a longer soaking time and rub more gently.

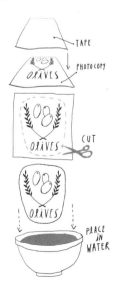

FAUX FRUIT PLATE

MATERIALS
Fruit
Contact paper
Bone folder
Scissors
Mod Podge Gloss
1" (2.5cm) flat brush
Bowl of lukewarm water
Large white plate

Trompe l'oeil is a French term meaning "trick the eye." Usually applied to painting, it is accomplished when a painter with exquisite skill, serious practice, and patience creates something so realistic that it actually looks three-dimensional. Well, the hardest part about making this trompe l'oeil fruit plate is convincing the people at the copy shop that you are not a weirdo for photocopying fruit. The fruit plate here is purely decorative—just like all the healthy food at my house—because you're not supposed to submerge the finished plate in water. Since the transfers are semi-transparent, a light colored plate looks best.

INSTRUCTIONS

1. Photocopy your fruit. Peel the back of the contact paper off and adhere the sticky side to the front of the photocopy. Burnish with a bone folder.

2. Slowly and carefully cut out the fruit shapes with scissors.

3. Paint a thin coat of Mod Podge on the face of the plate and set aside to dry.

4. Submerge the cutout fruit shapes in lukewarm water for 5 minutes, then gently rub off the paper backing.

5. Turn the cutout fruit facedown on scrap paper and coat the back of fruit shape with a thin layer of Mod Podge. Place the fruit shapes on the plate and smooth out air bubbles with your finger. Set aside to dry.

6. Coat fruit shapes with a thin layer of Mod Podge.

Another Idea
The same technique can be applied to metal, wood, and clay. Here a black-and-white image of a banana is shown on wood.

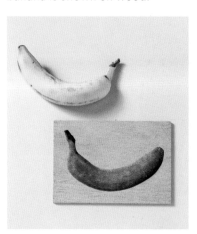

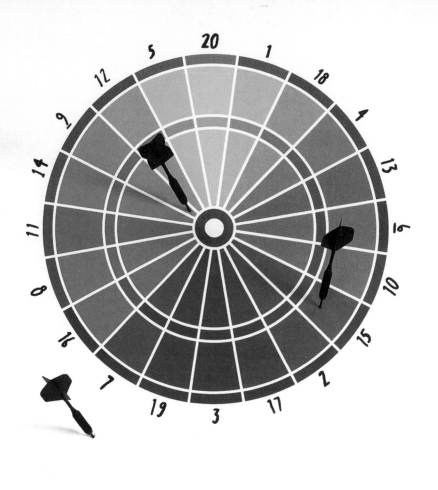

IRON-ON DARTBOARD

A dartboard gamely called "the bandit" hung in my studio and was a favorite boring-phone-call pastime. But every time I looked at it I got a whiff of some old guy's cigar smoke from decades past, not to mention the board colors were stale and common. To make it mine, I lost the dominating grid and filled it with full spectrum color. Now it also has a dual function: If I'm stuck in a color rut, I can throw a dart to select a color and break up my monotony. But you can fill it with any color you like to match your decor or to provide a striking contrast.

Make sure to read the manufacturer's instructions for the iron-on transfer paper and use the following as guidelines. You may want to print one extra-small piece and test before moving to the larger print.

INSTRUCTIONS

1. Scan in the template and fill in colors with a photo-editing computer program. Reverse the images. Print the 4 decal sheets (in reverse) onto the transfer sheets and assemble in proper formation. The images will appear backwards. Label the pieces counterclockwise 1–4 on the back to make sure you keep them in order.

2. Preheat the dry iron to the hottest setting and let it heat up for 5 minutes.

3. Lay the pillowcase on a hard work surface and iron it, then iron the cotton fabric. This removes wrinkles and moisture from both pieces.

4. Place the fabric on the hard work surface and place the transfer sheets facedown in the proper order. Lay the pillowcase over the transfer paper. Press with the iron, rotating the center of the iron to cover entire transfer area.

MATERIALS
Template (page 170)
Computer with scanner and photo-editing program
At least four 8 ½" x 11" (21.5cm x 28cm) Avery T-shirt transfer sheets
Iron
Pillowcase
26" x 36" (66cm x 91cm) piece of white cotton fabric
20" x 30" (51cm x 76cm) piece of white face board or soundproofing wood fiberboard (page 101)
Straight pins
Newsprint
3M Super 77 Multipurpose Adhesive
Staple gun with ¼" staples
Darts

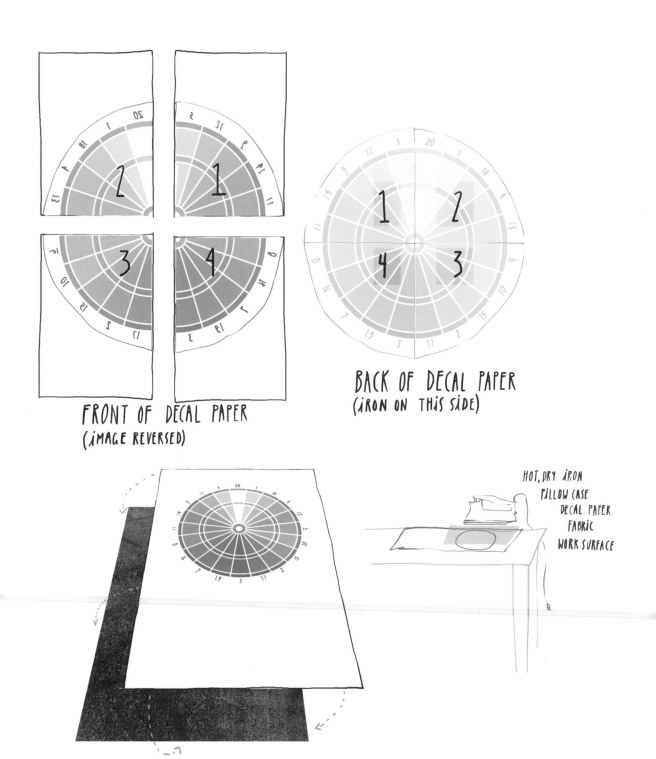

FRONT OF DECAL PAPER
(IMAGE REVERSED)

BACK OF DECAL PAPER
(IRON ON THIS SIDE)

HOT, DRY IRON
PILLOW CASE
DECAL PAPER
FABRIC
WORK SURFACE

Print Workshop

5. Lay the fabric over the white board or soundproofing board, place it in the correct area, and smooth flat. Pin one side of the board with straight pins on the edge.

6. Lay down some newsprint in a well-ventilated area. Lay the board faceup on the newsprint.

7. Pull the fabric away from board along the edge opposite the pins, leaving the pinned edge in place. Apply an even coat of spray adhesive to the board and lay the fabric print back over the board. Smooth out any bumps with your hand to achieve a flat surface.

8. Lift the board so it is perpendicular to the work surface. With the print facing away from you, fold the excess fabric along the glued side over the edge of the board.

9. Staple the fabric 2" (5cm) from the edge with a staple gun, placing a staple every 5" (12.5cm).

10. Remove the straight pins and turn the board 180 degrees. Repeat with adhesive along this side as in steps 7 and 8.

11. Repeat for the other 2 sides, taking care to pull the clipped corners taut.

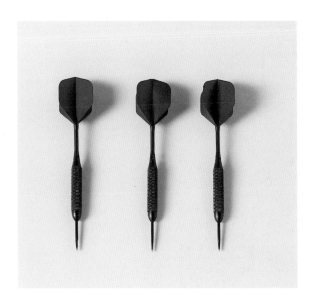

Another Idea
Scan a checkerboard (or find one at a tag sale or on the Internet) and iron it on a picnic blanket for a multifunctional (and cozy) game table.

TIP
If you want to play by the rules, position your bull's-eye 5'8" (1.7m) above the floor and mark the throwing line at a distance of 7'6" (2.25m) from the wall.

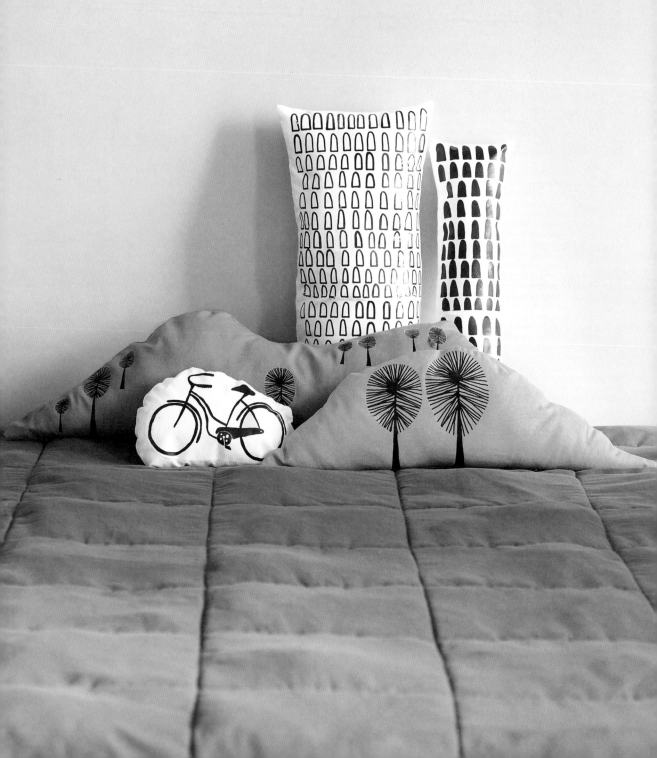

CiTYSCAPE PiLLOW SET

MATERIALS
Templates (page 171) or your
 own artwork
6, 8½" x 11" (21.5 x 28cm) Avery
 T-shirt transfer sheets
1 yard (91cm) white cloth
1 yard (91cm) lime green cloth
1 yard (91cm) dark green cloth
Iron
Fabric cutting scissors
Straight pins
Drafting tape
Fabric marking pencil
Sewing machine (optional)
1 spool white sewing thread
1 spool lime green sewing thread
1 spool dark green sewing thread
Sewing needle
Polyester fiberfill

I always marvel at the extreme styling of department-store beds. Forty-five pillows, three blankets, and a throw take up all the space that my body wants to sleep in. I wanted to make a "pillowscape" for my young cousin, but what's the point? So I thought, "What if those pillows could tell a story?" I like the variety of components and thought they looked a bit like buildings. If sewing ability was rated on a scale of one to ten, I would be a two, so just dig in!

INSTRUCTIONS

1. Print the templates or your own artwork onto the transfer sheets so that the images appear in reverse.

2. Fold a piece of fabric in half and place the decals at least 4" (10cm) apart on the fabric.

3. Following manufacturer's instructions and referencing the technique on page 139, iron the decals onto the fabric.

4. Holding both layers of fabric in your hand, cut out the shapes with scissors, leaving 2" (5cm) margins around the images. For the skinny building pillow, tile as shown (A).

5. Turn both pieces of fabric so the image is facing the other piece of fabric, or right sides together. Secure the perimeter with straight pins.

6. Tape the pinned sections to a sunlit window with drafting tape. Trace around the image with the pencil, leaving a ¾" (2cm) margin around the image.

7. With a sewing machine or by hand, sew a running stitch over the traced line, removing straight pins as you go and leaving 5" (12.5cm) of the traced perimeter open. Cut off all but ½" (13mm)

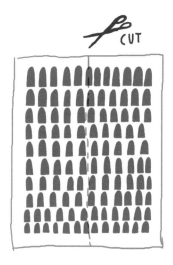

CUT

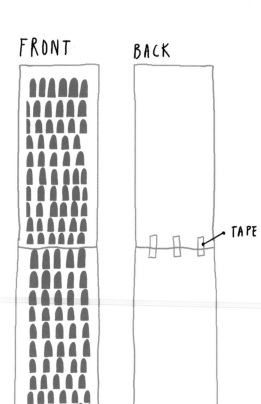

FRONT BACK

TAPE

of seam allowance.

8. Turn fabric right side out so the image faces out. Use your finger or a pencil to turn out any corners.

9. Stuff the case with fiberfill. Overstuffing will give a rounded appearance and may warp the image, so go with an even fill that can be patted flat.

10. Turn the seam allowances of the opening to the inside and pin the edges together with straight pins. Sew closed with a whipstitch. The stitches should be about $\frac{1}{16}$" (1.5mm) apart, and only as deep as necessary to create a firm seam. Leave a tail of thread when you start, and work several stitches over it to secure and hide the thread.

Other Ideas

Find a photograph of a building you would love to transfer, like the pyramids or the Eiffel Tower.

Transfer a photograph of a loved one so they can visit your city while you sleep.

Transfer a picture of your own house.

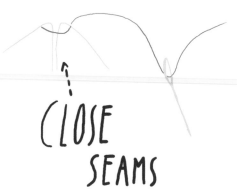

CLOSE SEAMS

RESOURCES

The vast majority of supplies used in this book can be purchased at your local craft, art, hardware, and fabric stores. Buying in person is ideal because you can carefully examine and handle your materials, avoid shipping costs, and support the local economy. Sure, the kid behind the counter is just biding his time 'til his next smoke break, but if his store doesn't stock an item you want, I'll bet he knows who does.

I have tried my best though to list online and mail order sources for all the products I have used in the book and that I use in my studio every day. And it is a biased list. I would rather have the guesswork come from my creative process and not the materials I am working with, you know? All the companies listed were selected because of my own personal preference for their quality and reliability. None of the recommendations were made with promotional consideration, just years of testing.

I am listing U.S. stores when available as well as the manufacturers of some items. This way, if you have the good fortune to live in an exotic land, you can contact themanufacturer and ask if anyone carries the product in your area or if they can ship something to you directly.

TiPS

Before we get to the good stuff, here are some tips on stocking your studio:

If possible, avoid buying large sheets of paper online. Online stores usually require you to purchase about ten pages of one specific paper to qualify for shipping, and shipping costs will be high if you buy a large amount. If you do buy a large size of paper, it will likely arrive rolled in a tube. The curl of thick paper (such as watercolor paper) will take a while to flatten. Note, however, that this does not affect rice paper.

If you know the brand name of the product you want, search the Internet for the manufacturer's website, and it will usually list local stockists. Then you can call a local store to check their current stock.

With inks and paints, a little goes a very long way. When you're trying out a product for the first time, buy a small tube to start. If you need more you can always buy more, and if you don't like the result you won't be stuck with an economy-size amount of waste. Also remember you can make any color with red, blue, yellow, black, and white!

Buying anything online with color—whether it's ink, paint, paper, or fabric—can be tricky. Photographs of product colors might not be accurate, and something as simple as the display settings on your monitor can completely change a product's color.

Materials that have been photosensitized—like cyanotype paper, fabric, and solar plates—are best used in less than six months. StencilPro is best used within one year.

Excluding foam brushes, it is best to buy brushes in person. Online photos won't show any imperfections, and the quality of a brush is just easier to judge in your hand.

Many stores give discounts to students and teachers if you ask. They know that both groups need a lot of supplies and have to get them somewhere. They want your return business, so let them indulge you.

Stores want to serve you. If there is a product you want that they don't currently carry, kindly ask the manger to special order it for you. This holds true especially for art stores. It would be impossible for anybody (even the big chains) to stock every product on the market, so they need to know what their customers want.

Unfortunately, many supplies don't come in travel size. If it looks like you have to order more than you want, gather some pals that are interested and split the cost of supplies among the group. Then when it comes in you can all have a good time making projects together.

STOCKISTS

GENERAL

Dick Blick
800.828.4548
www.dickblick.com
With a monster fine-art and craft selection, multiple locations, and a well-organized website, this is the king of all art stores. Good prices on most staple supplies and valuable promo information from time to time (everything from 20 percent off to free shipping) if you give them your e-mail address.

McClain's Printmaking Supply
15685 SW 116th Avenue
PMB 202
King City, OR 97224-2695
800.832.4264
www.imcclains.com
The best place for traditional printmaking needs. This store is run by printmakers and it shows: They know everything about everything in their store. They are always willing to share advice and answer questions. I love them and their amazing selection, especially their fine Japanese relief printing blocks, brayers, barens, and carving tools.

Savoir Faire
40 Leveroni Court
Novato, CA 94949
415.884.8090
www.savoirfaire.com

This is the U.S. distributor for many fine paints, brushes, paper, stationery, and journals. Although they distribute to many art stores, their website has some unique things. Watch for end-of-season sales when they unload the back stock; otherwise it tends to be pricey to shop here. My favorites are the Fabriano Medioevalis and Arturo stationery lines and their wide range of blank albums and journals.

Uline
800.958.5463
www.uline.com
You have to order in large quantities, but this is the place for any general item you find yourself using a lot. For example, I get sheets and rolls of kraft paper, butcher paper, and newsprint here. They also have awesome gift boxes, muslin bags and tags, craft-knife blades (get a bunch!), and packing tape. If you have reservations about ordering a large quantity, they will usually send you a free sample to try before you buy. Always calculate shipping costs before you purchase.

Utrecht
800.223.9132
www.utrechtart.com
Shares many of the high points of Dick Blick but with a fine-arts focus. No craft supplies here. Good and knowledgeable staff.

BLANK STATIONERY

Paper Source
888.PAPER.11
www.paper-source.com

Savoir Faire
(See above)

CANVAS MESSENGER BAG

Army Surplus Warehouse
P.O. Box 1523
Idaho Falls, ID 83403
208.529.4753
www.armysurpluswarehouse.com

CUSTOM-ETCHED STAMPS

Picture My Stamp
866.225.7346
www.picturemystamp.com
If you love your carved stamps so much that you want to sell your own line of them, go here. That's what we did! Woman-owned business fronted by the knowledgeable Susan.

XStamper
1661 West 240th Street
Harbor City, CA 90710
800.541.9719
www.xstamper.com
So many websites that sell custom rubber stamps get them here: Skip the middlemen and go right to the source. They also sell embossers, which press relief images into paper (similar

to a notary seal). They currently do not have a file uploader on the website, so call to get the exact e-mail address for the art department.

CYANOTYPE PAPER, CYANOTYPE FABRIC, CYANOTYPE GARMENTS

Blue Prints on Fabric
20504 81st Avenue SW
Vashon Island, WA 98070
800.631.3369
www.blueprintsonfabric.com
Pretreated fabric, scarves, and watercolor paper. Run by Linda Stemer. They will custom treat anything for you, and there is no question she can't answer. Website also has a good FAQ section.

CYANOTYPE SOLUTION KIT

B&H Photo Video
420 9th Avenue
New York, NY 10001
800.606.6969
www.bhphotovideo.com

Photographer's Formulary
(manufacturer)
P.O. Box 950, 7079 Hwy 83 N
Condon, MT 59826
800.922.5255
www.photoformulary.com

GESSOBORD

Ampersand Art Supply
(manufacturer)
800.822.1939
www.ampersandart.com

Dick Blick
(See above)

GLASS BOTTLES AND JARS

Sunburst Bottle
4500 Beloit Drive
Sacramento, CA 95838
916.929.4500
www.sunburstbottle.com
Unparalleled selection of glass bottles, but beware the shipping fees. Your local science or herbal store should also have some cool bottles stocked.

JOURNALS, ALBUMS, AND NOTEBOOKS

Moleskin
(manufacturer)
www.moleskin.com
Chronicle Books now distributes these beloved journals and planners so you can find them in most book stores and art stores.

LIQUID FRISKET

Dick Blick
(See above)

Winsor & Newton
(manufacturer)
www.winsornewton.com

MUSLIN BAGS

San Francisco Herb Company
800.227.4530
www.sfherb.com
The best prices I have seen happen to be at a local San Francisco joint.

Muslin Bags
P.O. Box 19284
San Diego, CA 92159-0284
619.861.6220
www.muslinbags.com
Huge variety of sizes on U.S. and imported bags.

MYLAR, CLEAR ACETATE, STENCIL FILM, FRISKET FILM

Grafix
(manufacturer)
www.grafixarts.com

PHOTO-EDITING SOFTWARE

Photoshop
www.adobe.com
You can download a free 30-day trial of this professional-level photo-editing program and mess around with it before you buy this amazing but expensive software.

Picasa
www.google.picasa.com
Free photo editing plus free
web albums.

Gimp
www.gimp.org
Free open source software.

RELIEF PRINTING BLOCKS, ETCHING TOOLS, INKS

McClain's Printmaking Supply
(See above)

SCREEN PRINTING INK

Dick Blick
(See above)

SOLAR PLATES AND PAPER

Box Car Press
501 West Fayette Street, #222
Syracuse, NY 13204
315.473.0930
www.boxcarpress.com

Dick Blick
(See above)

McClain's Printmaking Supply
(See above)

STENCILPRO

Circuit Bridge
(manufacturer)

722 Charcot Avenue
San Jose, CA 95131
408.428.9414
www.cbridge.com

TOTE BAGS

Bagworks
800.365.7423
www.bagworks.com
Manufactures and imports
tote bags.

Envirotote
800.TOTE.BAG
www.enviro-tote.com
If you need more than 50, con-
sider this place. Woman-owned
business that sews bags in the
U.S. Awesome quality, but not
cheap.

TRANSFER PAPER

Avery
(manufacturer)
50 Pointe Drive
Brea, CA 92821
800.GO.AVERY
www.avery.com

Office Depot
800.GO.DEPOT
www.officedepot.com

Saral Paper Corp.
400 East 55th Street, Suite 14C
New York, NY 10022
212.223.3322
www.saralpaper.com

Sheer Heaven Art Paper
Cre8it!/Gallery Different
Paper Arts
(manufacturer)
8 Chapala Road
Santa Fe, NM 87508
505.466.0270
www.dotcalmvillage.net

T-SHIRTS

American Apparel
888.747.0070
www.americanapparel.net
Sweatshop-free threads made
by this hipster stalwart.

Cheap Tees
800.758.1299
www.cheapestees.com
Sells inexpensive T-shirts by
multiple manufacturers.

WATERCOLOR CANVAS

Fredrix Artist Canvas
Tara Inc.
(manufacturer)
800.241.8129
www.taramaterials.com

WATERCOLOR PAPER AND WATERCOLOR PAINT

Dick Blick
(See above)

Savoir Faire
(See above)

GLOSSARY

Aesthetics. Philosophy that studies the experience of an artwork by evaluating its composition, materials, function, and expressive qualities.

Archival. Also called acid-free. Colorant, adhesive, sealant, or paper that does not have acids (low pH levels) that break down and change with time.

Barren. Handheld disk used in relief printing to press or burnish the paper to pick up ink from the relief block.

Brayer. Handheld roller used to spread ink onto a surface. Rubber brayers are used in relief printing; foam or sponge brayers are used for paint application.

Bone folder. A tool with a dull edge used to score, fold, or burnish paper. Can be made of actual bone or plastic Teflon.

Burnish. To rub with pressure.

Craft knife. Also called X-ACTO® knife. Aluminum pen shaft containing a disposable short, sharp blade used for cutting paper.

Colorant. General term for inks, dyes, and paints that contain pigments of color.

Composition. Arrangement of art elements in a piece.

Contact paper. Brand name of an adhesive vinyl sold in rolls. Sold as a protective film for surfaces; we use it to make stencils and water-slide transfers.

Cyanotype. A photographic printing process that creates blue print by exposing a substrate that has been coated in a light-sensitive solution and exposed to UV light. Invented by Sir John Herschel in 1842.

Embroidery. Design composed of stitches applied to a substrate with needle and thread. Type of thread usually used is floss.

Edition. A series of prints. When numbered and signed, they are referred to as a "limited edition."

Film positive. Sheet of transparent plastic that is adorned with a design made with opaque ink that prevents light from passing through onto photosensitive substrate.

Gouge. Knife used in relief printing whose edge has a V or U shape.

Image transfer. A variety of a printing process that passes design from one surface to another.

Impression. Substrate that received impression from printing matrix to an image on substrate, a print.

Kozo. Also called *washi* and *hosho*. Semitranslucent paper, inaccurately called rice paper, that is made of fibers from the mulberry tree. Strength makes it ideal for relief printing.

Mask. To block a surface from receiving colorant.

Matrix. The material that transfers design to the substrate.

Monoprinting. A printing technique that creates prints that vary in appearance. Similar to a printed painting.

Mod Podge. Brand name of acrylic gloss or matte product with a medium level of viscosity. Although it appears white when wet, it dries clear. Used as a light-duty glue and sealant.

Mylar. Brand name of clear film or sheet made of polyester or plastic. Although created from different substances, it is used interchangeably with the word acetate. Available in a variety of thicknesses.

Opaque. Not transparent; can't see through it.

Pigment. A synthetic or natural material that changes the reflected light to create color. Ground into a fine powder that is suspended in a medium to create a colorant (ink, paint, or dye).

Print. Any material that contains an impression from a print matrix that has been made by hand. Different from a reproduction, where image is replicated by photographic or mechanical means.

Proof. Prints that are not part of edition and are reserved for the artist. Usually the first set of prints done to check color and placement. Also called artist proof or A.P.

Registration. Used in printing to align the substrate and printing matrix for accurate color location.

Relief. A printing matrix made of wood, linoleum, or rubber that is carved with gouges. Areas that are carved away do not hold ink. Most common form is rubber stamp.

Screen print. A stencil that is created on a piece of cloth that allows paint to go through areas that are not masked by the stencil. Also called serigraph.

Sheer Heaven. Brand name of a semitransparent sheet that resembles vellum. Can be used for image transfer. Also can be used as a drawing or painting surface.

Solar plate. A steel sheet that has been coated with a photosensitive polymer that hardens to create a printing plate after exposure to UV light. Develops in water.

Squeegee. A tool used in screen printing with a wood handle and a plastic blade that pushes ink though a screen.

Stencil. A template made of film with open areas so ink and paint can be applied to the substrate.

StencilPro. Brand name of a mesh coated with a photosensitive emulsion that, when exposed in UV light, creates a stencil that is used as a silk screen. Formerly known as PhotoEZ™.

Stipple. To apply paint in a dabbing motion.

Substrate. Material or surface that is printed on.

Template. A pattern or outline used as a guide to replicate something.

Tromp l'oeil. French term for a two-dimensional rendering of a picture that is so realistic that it looks three-dimensional.

T-square. A technical instrument, often marked with measurements, used as a guide to draw and cut vertical and horizontal lines, like a ruler with a head that hangs off the edge of a work surface or cutting mat.

UV light. Ultraviolet electromagnetic radiation emitted by the sun. Awesome for cyanotypes, solar plates, and sunburns.

TEMPLATES

+ 200%

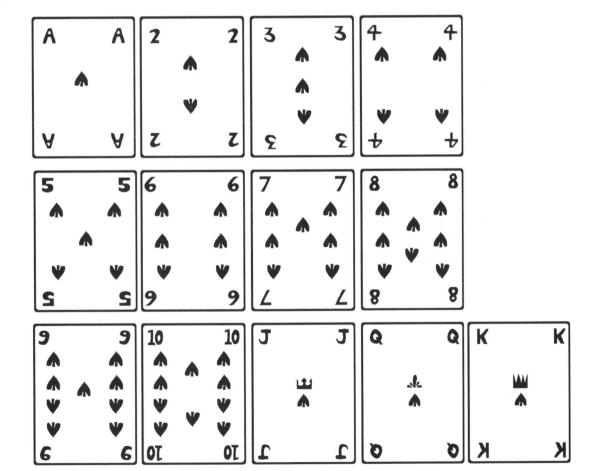

+230%

+ 175 %

abcdefg
hijklm
nopqrst
uvwxyz

100 %

HELLO

bon voyage

+ 200 %.

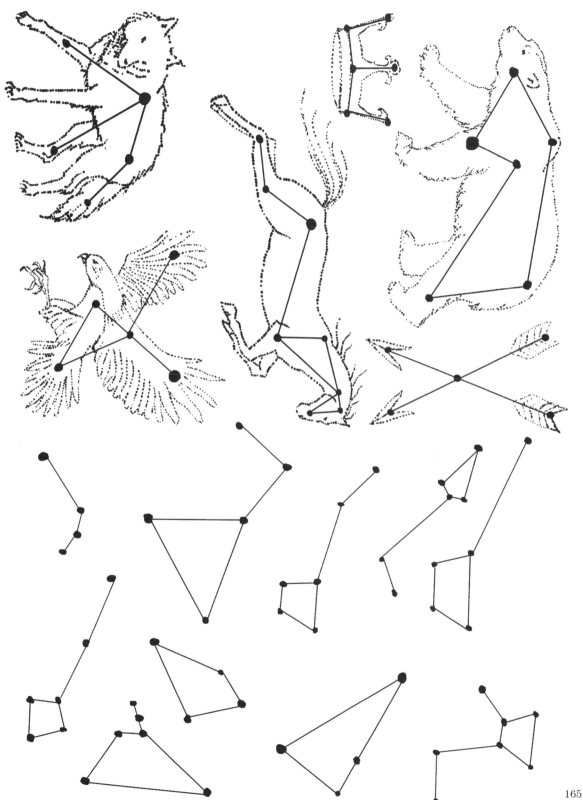

+180%

+140%

F

D

C

B

A

E

100%

OLIVES

PRESERVED LEMONS

PICKLED BEETS

+ 270%

ACKNOWLEDGMENTS

MOM (MARY BETH SCHMIDT)

ABBY, JESSIE + EMILY SCHMIDT

THOM O'HEARN
EDITOR COOL GUY

ROBBIE "WATER PROOF" BEERS

EVAN ALLAN GROSS (MOON, STARS)

DOUG ADESKO
Photos

KELLIE - BEAN MANAGER SUTHERLAND

AMY KAROL (GUIDANCE)

• SARA BALANDZIJA
• NICHOLAS LARIMER
• YOSHI NAKAMOTO ON DRUMS

SCOtt THORPE AND BREtt MacFADDEN

KIRBY KIM PAL, AGENT

book design!

ALLIE STARK (ASSISTANT)

CHI LING MOY — ART DIRECTOR
☆ ERICA SMITH AND EDITORS
BEtty WONG

PAUL WACKERS - - - - - - - - ->

LAUREN SMITH + DEREK FAGERSTROM

JUDITH DURANT (TECHNICAL EDITOR)

LIFE BOOK

INDEX

bon
voyage